What's in a Picture?

Uncovering the Hidden Stories in Vintage Maine Photographs

By Joshua F. Moore

Down East

∞

ISBN (13-digit): 978-0-89272-778-0

Printed at Versa Press Inc., East Peoria, Illinois

5 4 3 2 1

Down East
Books·Magazine·Online
www.downeast.com

Distributed to the trade by National Book Network

Library of Congress Cataloging-in-Publication data:
Moore, Joshua F., 1971-
 What's in a picture : broiler queens, floating house, and other hidden stories in
vintage Maine photography / by Joshua F. Moore.
 p. cm.
 ISBN 978-0-89272-778-0 (trade pbk. : alk. paper)
 1. Maine--History--Pictorial works. 2. Maine--Social life and customs--Pictorial
works. I. Title.
 F20.M63 2008
 974.1'040222--dc22
 2008027585

This volume would never have been possible without the foresight of the many Mainers who have collected, preserved, and shared their historic photographs with DOWN EAST over the past half-century. For their generosity and kindness I am forever grateful.

— Joshua F. Moore

Foreword

Along with the fabled rockbound coast and great North Woods, a rich sense of history is an integral part of the Maine mystique. The founding editors of *Down East: The Magazine of Maine* recognized this early on, and larded the magazine with articles and old photos showing what this corner of the world was like when shipbuilding, woodcutting, and farming dominated life here. Readers responded so favorably that history and nostalgia quickly became mainstays of the magazine.

As color printing improved over the years, however, the temptation to favor brilliant, fresh images in the magazine gradually curtailed the reliance on pieces illustrated with old black-and-whites. For a while stories from the days of yore became a relative rarity in the magazine's pages. To satisfy our many history-loving readers, the editors ultimately hit upon the idea of selecting at least one fine old Maine photograph to showcase each month. Inspired in part by the classic "Miscellany" page that concluded every issue of *Life* magazine in its heyday, the featured image in *Down East* would be accompanied by a short article explaining both what it showed and what it revealed. Within months after it was launched, the "What's in a Picture?" page had become one of the most popular features in the magazine.

Stroll the streets of any Maine town and you'll see why *Down East*'s readers took such an interest in these vintage photographs. Walking around virtually any municipality is as much an exercise in time travel as sightseeing. The foursquare old houses, the stolid brick storefronts, even the ancient maples transport us to an earlier day, and the effect is beguiling. But it's just an illusion; we can only imagine who was treading these streets a hundred or more years before us. That's where the wonder of old photographs comes in.

The houses lining the street I live on in Belfast, for instance, date from the mid-1800s, and aside from fresh paint their exteriors are remarkably unchanged from what they must have looked like originally. But it wasn't until a neighbor shared some images from a collection of historic photographs that I understood how my neighborhood actually appeared a century ago. One of the pictures shows a big house down the street with four women in simple, long dresses sitting out front. In the pathway to the attached barn stands a workingman with the family horse. It has the look of a rural Maine farmstead even though the place is only a few

blocks from downtown. By contrast, another shot portraying a similarly sized house up the street is a portrait of gentility. Embellished with pillars and ornate trim boards, the dwelling itself makes a statement, which is only underscored by the fashionably dressed lady and gentleman posing in the front yard by a magnificently flowering bush. Different as the two households appear, both fly the stars and stripes—just as many of us on the street still do today—and economic diversity remains a hallmark of our city. At a glance, vintage photographs like these answer all sorts of questions—and make the time travel even more vivid.

It's been more than a dozen years since *Down East*'s first "What's in a Picture?" photograph —almost an eternity in an industry where whole magazines are redesigned every other year. *Down East*, too, has changed with the times, but to this day many readers admit this quirky, backward-focused, but always illuminating feature is the first page they turn to in each new issue. Time travel, it seems, will never lose its allure among people who care about Maine.

— *D. W. Kuhnert*
Editor in Chief Emeritus

Introduction

History was not out of focus, it was not boring, and it certainly was not staged. Yet so many vintage photographs incorporate some or all of these flaws, whether it's the shot of a bowler-wearing shopkeeper standing in front of his store or a handful of women in hoop skirts arranged on a front lawn. History books seem to be bursting with variations on what, when I was a newspaper editor, we called the "grip-and-grin"—a photograph of a business owner holding an oversized check as a service-group volunteer accepts it—and these scenes were no more interesting a century ago than they are now. Instead, the images that made for great photographs at the turn of the twentieth century contain the same key elements as those that are most memorable today: dramatic action, careful composition, and a handful of noteworthy details.

Another critical, and often overlooked, similarity between the great photographs of yore and those of today is clarity. An interesting subject captured in a blurry black-and-white image becomes an obscure history lesson, one that immediately places an inappropriate separation between ourselves and our forefathers. A tack-sharp image, in contrast, immediately creates a connection, no matter if the scene depicted transpired in 1980 or 1890.

These are the types of photographs that I have sought out over the years for my monthly column in *Down East*, as I attempt to share images that not only tell something about the way life in Maine was, but also help provide some insight into why the Maine way of life looks and feels the way it does today. My search for arresting images has sent me to the back rooms of historical societies in small towns like Camden and in larger cities like Bangor. I regularly probe the depths of the Internet, where large depositories like the Maine Memory Network, stock-photography groups such as Corbis, and even eBay have proven to be great sources for spectacular, vintage Maine images. Finally, I have been fortunate enough to have received many wonderful historic images from loyal magazine readers, people who often have little or no information about a photograph in their possession. The tattered item discovered in an album or attic may contain the image of a relative, or perhaps all they know is that it was taken in Maine and so might be of interest to me. Oftentimes I receive a note from a beneficent contributor after his or her photograph has been published, telling me that my article

taught them new information about their relations and the scene depicted.

Indeed, locating an arresting image is only the beginning of determining what is actually in a picture. A high-powered magnifying glass and, increasingly, the ability to zoom in on an image on a computer screen allow me to scrutinize every detail in ways that historians have never been able to do before. Within a dramatic photograph taken during the Bangor fire of 1911, for instance, the length of the shadows on a building helped me tell precisely what time of day the photograph was made. In another image, a smudge in the window of the ice-covered ruins of Granite Hall in Augusta became a human face when the photograph was turned into pixels. Even a subtle detail like the ring on the finger of a model used by a Saco stove company reveals itself to be a telling prop by an advertising photographer to appeal to Maine wives—an especially ironic touch when we learn that the model was, in fact, unmarried.

In the end, though, I have learned that all of the modern gadgets in the world do not compare to personal interviews in unlocking the information hidden within a vintage photograph. It took me months and a bit of luck to determine that a charming photograph of a dapper gentleman on a railroad platform was taken at Strickland's Ferry, south of Livermore, but it was not until I talked to a local historian that the friendship between the subject, Leonard D. Alger, and photographer Silas R. Morse emerged. Suddenly Alger's contented smile made perfect sense in a way that it hadn't before, and I could practically imagine the New Jersey haberdasher's bliss during his Maine vacation. Likewise it was not until after I had talked to an Aroostook County farmer that I understood the appreciative expression on Canadian Medley Hartley's face back in 1980, as she watched her American neighbors loading potatoes for her during a border protest.

It is the combination, then, of detailed research and personal conversations that enable me to find the deeper stories vintage Maine photographs can tell us. While a photograph captures a split-second of history, attention to the details contained within that image can tell us not just what's going on in the photograph, but what has transpired to bring the scene to this point. In the best cases, we can even deduce what likely followed after. In this way these photographs tell us not just what's in a picture, but what is in Maine and, perhaps in some small way, what is within ourselves.

— *Joshua F. Moore*

What's in a Picture?

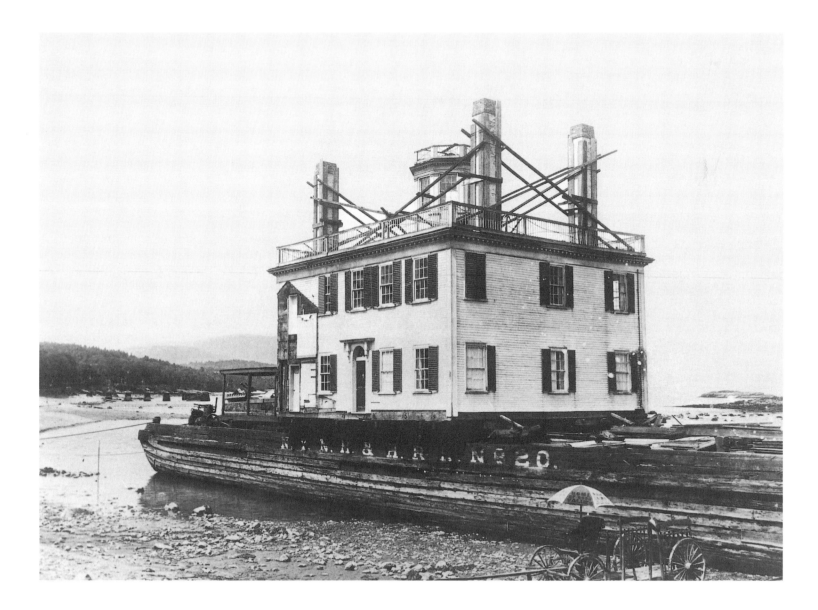

Beached Mansion

An impressive houseboat came

ashore in Rockport back in 1925.

When longtime summer resident Donald D. Dodge stumbled across this Federal-style house tucked on a Phippsburg backwater in 1925, he knew he'd found an appropriate home for his oceanfront property on Deadman Point in Rockport. Originally built in 1806 by ship captain Thomas McCobb and designed to be "the most beautiful house in Maine," the home had become known as Spite House because it was deliberately built to overshadow a family home McCobb believed had been usurped by a stepmother. Dodge, unconcerned both with the house's contentious past and the eighty-five-mile voyage required for it to reach Rockport, stipulated that the house, its cupola, and all four chimneys be moved intact and that none of the great home's plaster walls be cracked during the operation.

This remarkable photograph, made shortly after Rockland captain John Snow had beached Spite House in late July 1925 (after a two-day layover in Rockland so extra pumps, including the wheeled one at left, could empty the nearly flooded barge), shows that the wooden scow has been further burdened with Spite House's granite foundation slabs and even another whole house. The 1796 Stover House from South Harpswell was dismantled for the journey, but its windows and doors are visible stacked at right.

Presumably just moments after this image was captured, crews began unloading Spite House in the same manner it had been loaded—on greased skids, drawn by horses hauling lines passed around a windlass. Some of the 2,000 feet of timber used to stabilize the structure are visible bracing the chimneys, while strips of lath and an interior door peek out, left of center, from the scar created when an 1850 ell was left behind in Phippsburg.

One enterprising soul has already capitalized on Spite House's arrival, pulling his horse-drawn wagon and its "Home of Good Values" umbrella onto the mudflat to peddle supplies—or maybe just refreshments and snacks—to the workers unloading the great house.

After it was unloaded and firmly anchored in its new surroundings, the grand home was extensively renovated and Dodge, a noted horticulturalist, created elaborate Colonial Revival gardens. But on moving day, after all the painstaking preparations Dodge and his crew made—each floor joist, at center, has been carefully marked—they seem to have overlooked one of the simplest precautions. Despite the promise of rolling swells and brisk sea breezes on the journey, the movers closed just one set of wooden shutters—an oversight, perhaps, or possibly Mr. Dodge just couldn't wait to fling open the windows and take in the views of the Camden Hills, at left, from his proud new home.

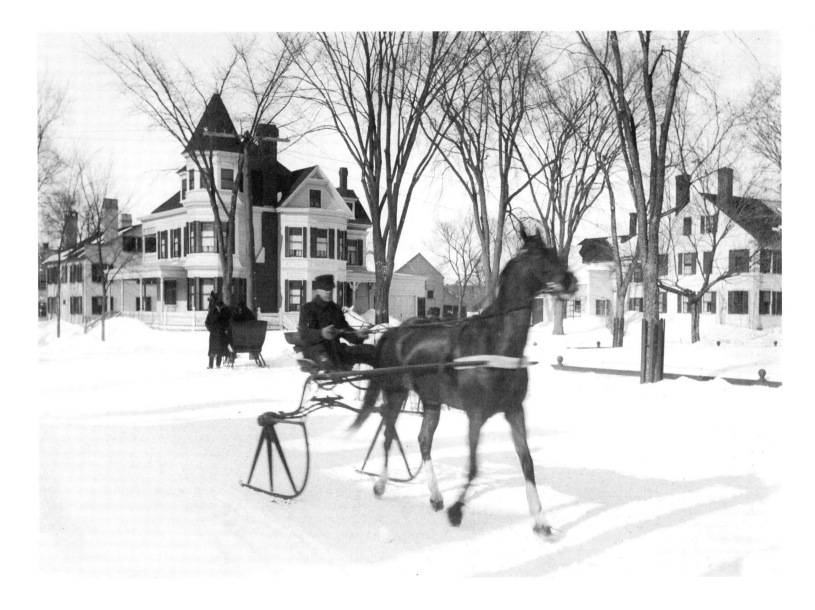

Racing Strides

A snowy boulevard in Saco made for a perfect racecourse almost a century ago.

These days most drivers dread a heavy snowfall, but nearly a century ago a good dumping of the white stuff was like raising the "start your engines" flag for anyone with a horse and sleigh. It was especially welcome around Eastman Park in Saco, where local photographer Charles E. Moody set up his camera in 1912 and caught racer Joseph Newell warming up his pacer. The park served as a finish line for the quarter-mile sprints that began at the North Railroad Station on North Street, one of many such impromptu racecourses that sprang up in Maine cities and towns during the winter. "Many a coachman, unknown to his employer, contrived to drive around to the speedway, perhaps with a horse he had been quietly conditioning, in the hope of indulging in a brush or two in the keen air," wrote Edwin Valentine Mitchell.

Judging by Newell's sleigh, though, he took more than a passing interest in such races. Instead of driving a standard Portland Cutter like the one behind him, left of center, he has retrofitted a sulky with short runners instead of wheels. Newell likely learned from racing on the frozen Saco River that a sulky could out-perform a sleigh on ice, and has decided to adapt the technology for the snowy surface of Main Street. His unique speedster has begun to draw a crowd: the bearded gent behind him who has left the comfort of his sleigh to watch Newell might well be John B. Gregory, the agent of the Saco River Lumber Company who owned the impressive Queen Anne behind him. And while this small group doesn't compare to the numbers who would gather here for the regular Sunday afternoon races, Newell seems to have attracted a competitor, as the white horse barely visible over his right shoulder appears ready to go head-to-head.

For racers, conditions didn't get much better than this. The snowdrifts are deep enough to almost cover the low railing, at right, that surrounds Eastman Park, but the small amount of snow on the rooftops indicates that it's been a day or two since the storm and so crews have had time to roll the road smooth. Only the horses might prefer different conditions: they probably consider the frozen fountain, just visible behind Newell, a cruel reminder of warmer days.

To capture this wintry scene, Moody had to have practically stood on the trolley tracks that crossed this well-to-do neighborhood, ironic because the trolley—and the automobile that would come after it—spelled the end of the horse and buggy and likewise the end of the North Street races in Saco. If not for Moody's photograph and the ongoing presence of the Gregory and Eastman houses that still lord over this village square, this scene might have melted away like a February snow.

Blaze of Glory

A Maine military hero's summer home had perished long before this fire in 1940.

The battle was already lost by the time a crew from the Brunswick Fire Department put their hoses to work on this inferno at Domhegan, Joshua Lawrence Chamberlain's former twenty-three-bedroom summer estate on Simpson's Point, back in May 1940. In this historic photograph you can see that the roof on the two-story ell, at right, has already collapsed, and a few flaming timbers are all that remain of a single-floor dinner shed, at far right. Smoke seeps from the eave below the main house's right-hand dormer, and the widow's walk above has begun to disappear behind a veil of smoke. The men in the foreground may well be caretaker Ernest Prindall and one of his sons; both realize, perhaps, that they and their family of six would lose all of their possessions in the blaze. (A dog, at lower left, seems unharmed.)

Just moments after this dramatic photograph was taken, firemen were able to get water from their five-hundred-gallon tanker truck and possibly even from the shore of Casco Bay only ninety yards away, preventing the circa-1789 structure from collapsing like the ell. The charred shell of the main house remained standing for another sixteen years after this remarkable photograph (selected from the collection of longtime Brunswick fireman Alfred "Freddy" LeTarte) was taken, but Chamberlain's cottage would shelter its inhabitants no longer.

Had he been alive to see it, Domhegan's demise might have actually been a relief for Brevet Major-General Chamberlain, who had renovated the former church building-turned-ship-yard bunkhouse just a few years before retiring as president of nearby Bowdoin College in 1883. Chamberlain enjoyed sailing his schooner, *Pinafore,* from the wharf here and reportedly cherished the spot so deeply that he had his trusted warhorse, Charlemagne, buried on the site (though searches of the property have never been able to locate the horse's grave or any remains). In the 1890s he unsuccessfully tried to use the property as a summer art colony, and by the early twentieth century he had taken to hiring it out as an inn. By the 1930s, with Domhegan having passed to Chamberlain's daughter, the estate remained largely vacant, save for the Prindalls.

In the end, Chamberlain, who so respected his Confederate adversaries that he had his men salute them when he received the formal surrender of weapons and colors at Appomattox, might have been pleased to see his beloved summer residence go up in a ball of fire, rather than fade away like so many old soldiers.

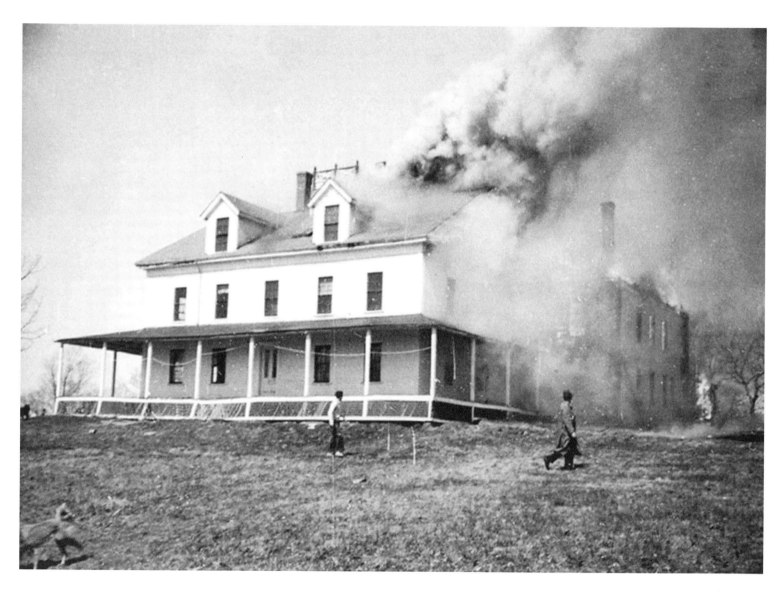

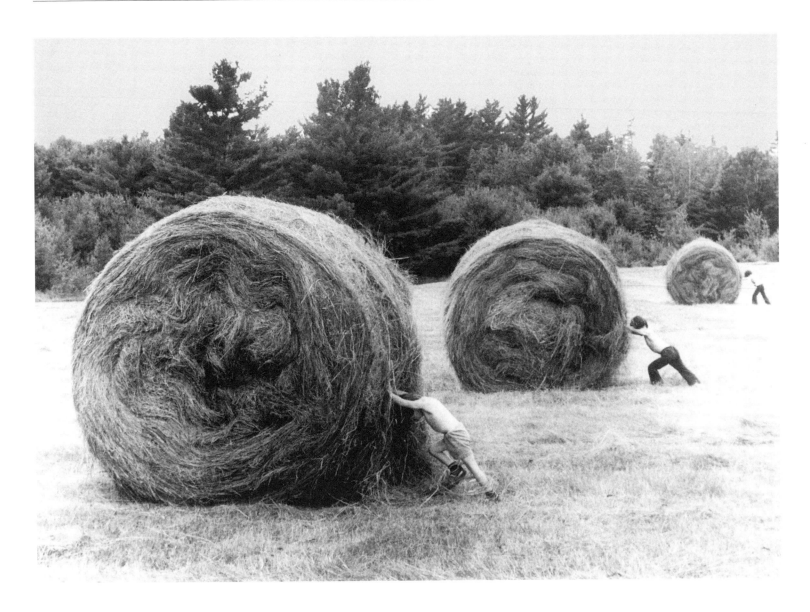

Rural Perspective

A jokester cameraman captured the strength of Maine's agricultural movement during the 1970s.

There is something about the Maine air that makes people here so strong. That's the message that an unknown photographer was trying to convey when he posed three young brothers in a Waldo County field back in September 1978. By arranging the brothers from smallest to largest—four-year-old Christopher Verrill appears at left, with Scott, 6, in the middle, and James Verrill, Jr., 9, at far right—the cameraman has accentuated his perspective of three enormous rolls of hay. Other subtle touches also contribute to the effect: from right to left, each shirtless boy leans progressively harder into the bales, leading the viewer into the image. And while the two lads at right wear dungarees, the boy farthest to the left is dressed in shorts—another tweak that draws attention to him and his oversized bundle.

The bundles, of course, are the one detail that gives away the photographer's secret. Created earlier in the week by rolling the hay directly on the ground like a snowball, the bales appear to be nine or ten feet in diameter—ideal for illustrating perspective, but far too large to move even by tractor (by comparison, the largest bales made today are around eight feet in diameter and can weigh more than two tons). This system wastes a lot of hay, as shown by the stalks wrapped around the legs of the boy at center, and results in a loose, irregular roll (note the rough surface and jumbled spiral of the bale at left). In addition, such massive rolls have a tendency to topple over and break open, increasing the risk that rainwater will soak into and ruin the entire bale. Modern chamber-style balers, in contrast, create a smooth package that can easily be moved by trailer or pickup truck and shrink-wrapped in white plastic.

The joke behind this remarkable photograph, of course, is that these young men weren't the ones who possessed superhuman strength, but rather the farmers who created their props and who continue to work Maine's rural landscape. Who knows—perhaps there really is something invigorating about the air here.

Steamer on Ice

A creative captain helped

this Maine paddle wheeler

beat a winter gale.

Those who champion the benefits of fiberglass or steel ships over wooden ones would have had a tough time arguing with Captain William Roix of the steamship *Katahdin,* pride of the Bangor-to-Boston run, shown here after surviving a winter gale back in 1886. Though the 241-foot vessel sustained some damage to its bulwarks and name-boards, at far left, shortly after it passed Cape Ann, otherwise the proud steamer fared remarkably well during its ten-hour battle with Mother Nature. Its only shortcoming turned out to be a lack of fuel, an obstacle Roix's crew handled ingeniously by feeding the *Katahdin*'s cargo, furniture, and even non-structural bits of the ship itself into the hungry boilers. Photographer Lafayette Newell recorded the evidence of this commonsense solution when he stood on an ice-covered wharf in Portsmouth, New Hampshire, and took this remarkable photograph just moments after the battered ship found shelter. A naked wooden knee, just right of center, still supports the ice-encrusted railing and deck above, the bulkheads and bulwarks that once covered it having been stripped off as fuel. An ice pick, at left, rests beneath the icicles covering the paddle wheel itself, probably abandoned by a crewmember who would have cherished the feel of solid ground after such a night at sea.

Perhaps more remarkable than the damage that the two seamen at far left are studying is what remains intact aboard the *Katahdin.* The glass in the doors on the second level appears unbroken, and a tiny wind-indicator flag, at upper left, still blows from the flagpole on the ship's bow. The scrollwork covering the paddle wheel looks as striking as it did when the ship slid down the ways in 1863, and the massive square beams that support the paddle wheel are unscathed and probably helped the ship retain its shape during the storm. The most disturbing item rests in the doorway at lower right; though it appears to be a small, frozen dog, it is almost surely just a frozen bit of carpeting or even a chunk of ice.

It would only be days before this proud steamer put to sea again, returning to her regular route up Penobscot Bay and making stops in ports such as Rockland, Camden, and Winterport before finally arriving in the Queen City or, when ice shut down the Penobscot River, in Bucksport. Along with the steamers *Cambridge* and *New Brunswick,* the *Katahdin* helped provide passenger service six days a week in summer, four in winter, between Boston and Bangor. Her reliability would make her, like her namesake on Moosehead Lake, one of the most beloved of all ships ever to ply Maine waters.

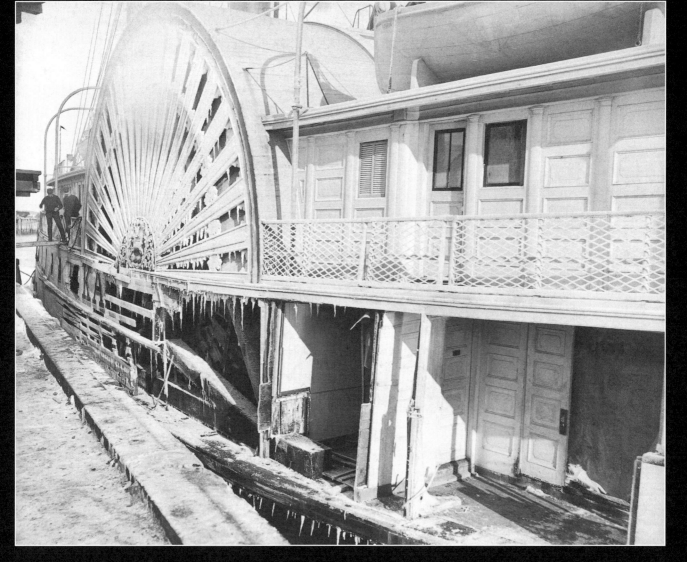

Blood Red Carpet

A Bangor movie premiere foreshadowed dark times for two celebs in 1984.

On its face, this festive scene in Bangor should have been enough to warm a moviegoer's heart. The darling girl in her bows and ruffled dress is just dying to put her finger into the gooey frosting of a tremendous square cake, while the dapper gent beside her is presumably encouraging her to refrain from making mischief. Look a bit closer, though, and you'll see that the man clutching a beer bottle and opener is none other than Stephen King, Maine's own master of horror, and the innocent preteen is a nine-year-old Drew Barrymore. It was 1984, and they had gathered at the Bangor Civic Center following the world premiere of *Firestarter*, in which Barrymore played the incendiary lead character. Queen City bakers had created the delicious display as an exact model of the marquee poster that promoted King's thriller. The celebrations were apparently in full swing when press photographer Whitney Draper snapped this image, as virtually all of the people behind King and Barrymore have a drink in hand.

But there is less festivity here than one might imagine. After viewing the premiere, King was quoted in *Cinefantastique* magazine as saying: "I was extremely depressed. The parts were all there, but the total was somehow much less than the sum of those parts." The Bangor novelist was wrestling with personal demons, too, having grown addicted to alcohol. "My nights during the last five years of my drinking always ended with the same ritual: I'd pour any beers left in the refrigerator down the sink," King wrote in his book *On Writing*. "If I didn't, they'd talk to me as I lay in bed until I got up and had another. And another. And one more."

And Barrymore, who had shot to fame two years earlier in Stephen Spielberg's *E.T.: The Extra-Terrestrial* and seemed destined for a bright future, reportedly had first tasted champagne months earlier at the *Firestarter* wrap party. She would spend the rest of her childhood battling addictions before turning sober in the early 1990s and emerging as a sought-after actress, activist, and film producer.

King too would find sobriety a few years later, but he was already demonstrating a big heart. He was responsible for bringing *Firestarter*'s world premiere to Bangor, an event that drew some nine hundred people to the Opera House and raised ten thousand dollars for Northeast COMBAT (since renamed Northeast CONTACT), a local consumer-advocacy group. King's philanthropic activities grew from there, supporting the Bangor Public Library, creating a world-class baseball park, and contributing to literacy and scholarship programs statewide. For both King and Barrymore, strength of character would eventually conquer inner darkness.

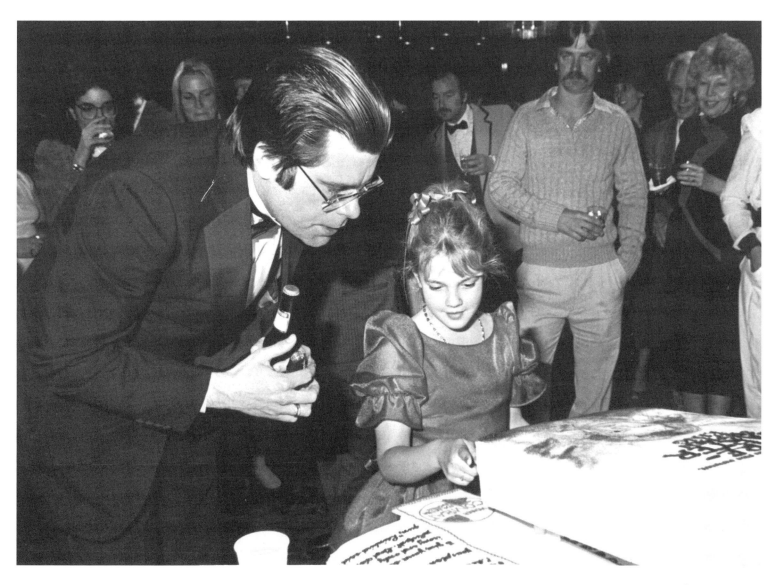

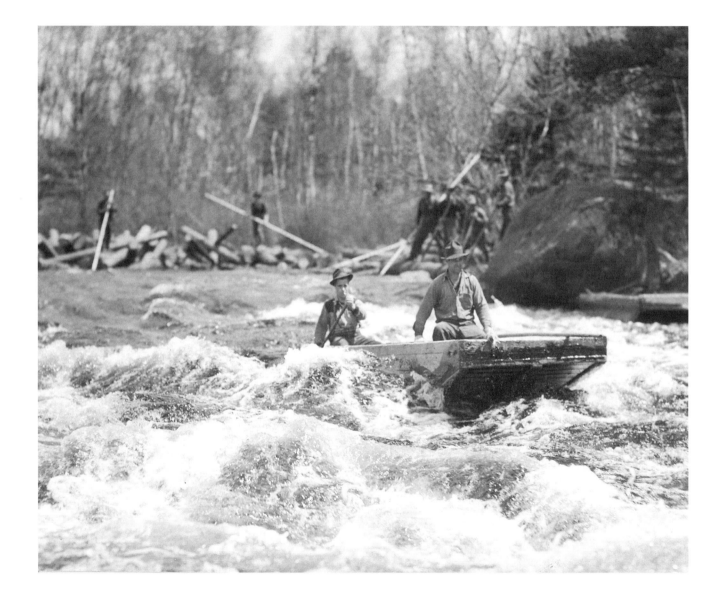

Spring Drive

Maine rivers represented a way of life a half-century ago.

Anyone who has weathered a Maine winter can relate to the smile on the face of the master river driver seated in the bow of the unusual wooden scow in this classic photograph made during a spring log drive on the Machias River back in the early 1950s. After a frigid winter spent felling, hauling, and loading timber in the Maine woods, for these rugged loggers the log drive represented more than just the release of millions of board feet of pine and spruce into the state's great rivers—it meant a roiling, torrential release from winter's frozen grasp. Despite the brimmed hats sported by the loggers on the shore in the background and the cigarette that dangles casually from the mouth of the sternman, at center, these men were all mindful of the fact that river driving was still an arduous, dangerous way to make a living. (The very plunge that this dapper duo is descending was known as Carrick Pitch, after the logger who died while freeing a logjam in this spot years earlier.)

Scenes such as this one would become increasingly rare on Maine's great rivers in the decades after this photograph was made, as modern trucks and heavy equipment—not to mention new environmental laws—made highways and woods roads more efficient than rivers in moving timber from the seemingly endless North Woods to the mills downstream. But Down East in Washington County, where a forty-mile stretch of wilderness continued to separate the logs from the mills that could turn them into profit, the spring log drive still represented the quickest way to market.

To the men who rode the last of Maine's log drives, however, the display of bravado captured here might be somewhat less impressive than it appears in this photograph. They might notice that the long pickpoles wielded by the two men at far left, for example, are far too stout to have been of any practical use in dislodging a stubborn key log within a logjam. But their exaggerated size and pale color does make them far more visible to this photographer's camera, which must have been situated on a rock within the river itself. And while the four men just right of center make an impressive backdrop, hunched over their peaveys in an artistic cluster beneath the early spring foliage, one has to wonder why they are not spread out along the shore, clearing errant logs that might not otherwise make it downstream to the St. Regis Paper Company's mill in Whitneyville.

Was this river driver really as pleased as he appeared when this photograph was staged during a log drive more than fifty years ago? Perhaps not, but on a heaven-sent day such as this one, his smile might have been more genuine than even he would have cared to admit.

Bunting for Belfast

No one wanted to miss this steamship's arrival nearly a century ago.

Most Mainers don't need an excuse to get outside and enjoy a sunny June afternoon, but even the most reclusive of Waldo County residents couldn't resist the inaugural arrival of the steamship *Belfast* to her namesake port in 1909. More than two thousand people crowded onto the Eastern Steamship Company's wharf at the foot of Commercial Street to watch the enormous "Great White Flyer" come alongside. (The largest of the steamers plying the Bangor-to-Boston run, she was so huge that she had to back into deeper water before turning around and departing.) Flags and bunting hang from every eave and window in the turreted terminal building, and even the tops of the pilings have become seats for a handful of bold couples, at center. One chap, barely visible just right of center, even leans out a second-story window to welcome the ship.

The unknown photographer of the Eastern Illustrating and Publishing Company who captured this surprising image had the best seat in the house, of course. He must have finagled his way onto the maiden voyage of this 320-foot-long, steel-hulled ship in Bath, where she'd just been completed at the same shipyard that today produces the latest generation of destroyers. But the tremendous length of the *Belfast* meant that he was unable to capture both the ship and the crowd assembled to greet her. His vantage point on the upper deck near the ship's stern allowed him to capture a more candid scene, though, from the gents in their straw boater hats, at far right, to the bonneted women in their billowing blouses and skirts. A telling detail is the young girl leaning on the rail at lower right; her fascination with the *Belfast* appears to have faded during the trip up Penobscot Bay, and she no doubt would prefer to be wandering the ship's mahogany-trimmed halls or playing in one of its 222 berths.

Indeed, even some of the spectators on the wharf appear to be losing interest in the *Belfast*'s arrival: the young ladies just left of center gaze at the receding tide below, and some of the wagon drivers at far left have actually turned their backs to the harbor. They may be more interested in the goings-on at Fields S. Pendleton's shipyard, at upper left, where low tide has caused two schooners to list; a three-master nearby may soon be beached as well.

In the years after this photograph was taken, more people would turn their backs on steamers such as the *Belfast*. Though the proud ship sailed her route for another twenty-six years, the popularity of the automobile would give rise to a new bridge across the Passagassawakeag River in 1921 and an even more impressive span, the Waldo-Hancock, over the Penobscot River ten years later. The *Belfast*'s party would be over soon enough.

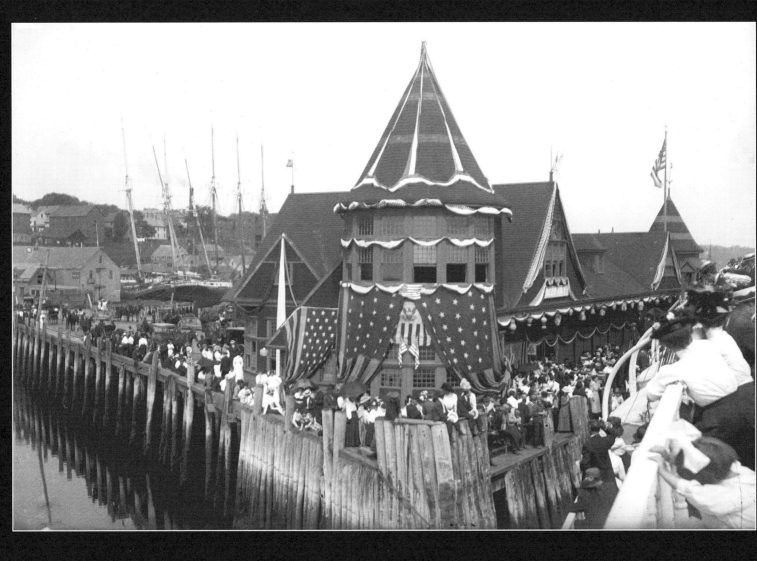

Lindy's Layover

America's most famous aviator wasn't afraid to get wet during one of his frequent visits to Maine.

Surely Colonel Charles A. Lindbergh never had to check his own oil. Yet the former airmail pilot insisted upon doing just that during a stopover at the Portland Municipal Airport in Scarborough in 1929, two years after his historic nonstop solo flight across the Atlantic. Perhaps he was particularly concerned about his precious cargo on this flight, as his Loening Air Yacht was carrying his fiancée, Anne Morrow, and her family back from their summer home on North Haven Island to New York. The downpours have already created mud puddles, at lower left, at the tiny airstrip and Lindbergh's suit and leather aviator's cap seem quite out of place as he crouches with a grease-gun in the rain on the pontoon of his amphibious biplane.

This remarkable photograph was probably taken in late May, just a few days before Lindbergh and Morrow married in New Jersey and then slipped back to Maine for their honeymoon. Their cruise along the New England coast would be one of the couple's most blissful times. "Today is one of those gorgeous blue Maine days: lots of little white clouds on the horizon, the pine trees sharp and black-green against sea and sky, and between islands, far away, the soft blue of other shores," Morrow Lindbergh wrote in her diary during that trip. But just two sentences later, her tone turns dark when she discusses the paparazzi who would pursue the Lindberghs for the rest of their lives. "They found us again this morning—the terrifying drone of a plane hunting you, and boats. I don't feel angry about it any more—it is inevitable."

Indeed, the Morrow estate on Deacon Brown's Point in Penobscot Bay would prove to be a crucial retreat for the Lindberghs, as they used it to escape the media spotlight while coping with the personal tragedy of losing a son and the public outrage over the aviator's political statements prior to World War II. For whenever Lindy returned to the mainland, either at a muddy airstrip in Scarborough or the more impressive airport in Portland's Stroudwater neighborhood that replaced it a decade later, the cameras found him. The lone eagle, it seems, could be alone no more.

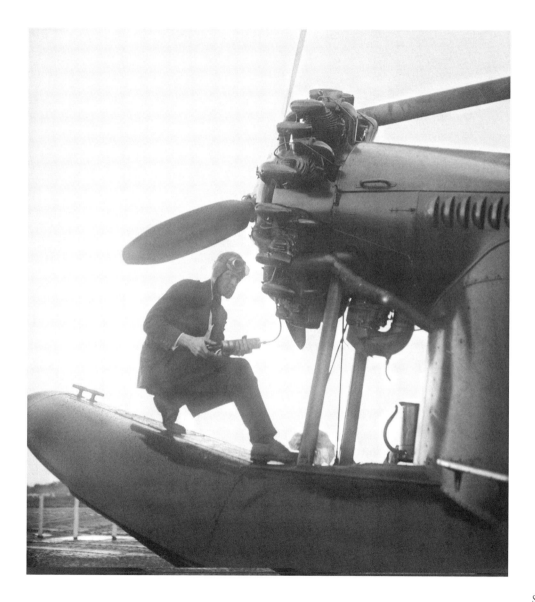

Dam Diver

A brave crew helped harness the Penobscot River's power in 1923.

Sometimes seniority has its benefits. That must have been what these construction workers were thinking as they watched a helmeted colleague climb off a makeshift barge and into the frigid waters of the Penobscot River in Bangor back in 1923. The wooden ladder faintly visible beside him would have helped this diver from the H.P. Cummings construction company reach the bottom some twenty-two feet below, while the weights strapped around his midsection and his heavy boots would have restricted his movements once he got there. His tattered cloth suit, with its knee-patch just breaking the water's surface, would have provided little insulation against the cold, though his bare hands would have negated any such comforts anyway. His fragile lifeline to the surface, of course, was the airhose attached at the rear of his helmet and coiled carefully by the burly man at center.

By the time this remarkable photograph was snapped by a cameraman standing on the Brewer side of the river, supervisor Percy Johnstone, who was likely the well-dressed gent at far left, and more than fifty of his workers had been on the river for months repairing damage the forty-eight-year-old dam had sustained during a spring freshet. Nearly three hundred feet of the wooden structure, which had originally been built to provide the Queen City with drinking water, had been wiped out and needed to be replaced. While repairs were under way, most of the Penobscot's water was routed through the long, narrow gatehouse, at upper right, the forebay, just left of center, and the turbines that had been installed a quarter-century earlier within the waterworks building, at far left. The pilings, at left, and the cribwork in the background, at right, formed a framework some 288 feet long and 20 feet wide. This was then filled with concrete and boulders to anchor the dam to the river bottom.

Remarkably, Johnstone was able to complete most of the repairs by late November, before the ice had set in, at a total cost of $150,000. The quality of his workmanship is still evident today; while the wooden section of the dam gradually deteriorated after the city ceased pulling its water from the then-heavily polluted river in 1957, the concrete portion still stands high and dry on the Brewer side of the river. Today low-income Mainers enjoy the view of this section of the Penobscot, as the long-vacant waterworks building has at last been refurbished as efficiency apartments.

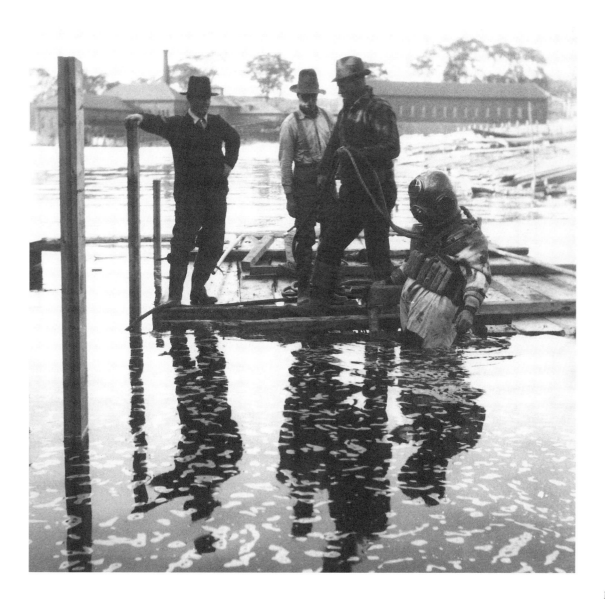

The Pause That Refreshes

A carefully composed photograph captures a relaxing late summer afternoon in Camden.

Theresa Parker Babb knew how to shake things up in turn-of-the-century Camden. The wife of the superintendent of the Knox Woolen Mill in town, Babb, at top, second from left, used her social standing and ambition to create the Camden Community Hospital, reach the summit of Maiden Cliff with the Camden Outing Club (and in a skirt, no less!), and discuss literature at the Monday Evening Reading Club. She also used it to round up models and locations for her budding photography hobby. In this striking image, captured on Shermans Point in Camden's outer harbor during late summer 1900, Babb has convinced three friends and an older bespectacled chaperone identified as Miss Merriam, at bottom, to perch with her at low tide on the seaweed- and barnacle-covered rocks. Despite the sweltering afternoon sun, the two women at right wear dark, heavy woolen skirts and tight collars, while Babb and the woman at left are dressed in lighter cotton clothing. The labels on the glass bottles are illegible, but we can only guess that the dark liquid contained within the bottles was Hires Root Beer or one of scores of sodas bottled in Maine at the time, rather than the scandalous liquor that some modern viewers might assume it to be. The ruse is furthered by the scowl on Miss Merriam's face, at lower center.

Such scorn is, of course, yet another deliberate detail in this careful composition. The person behind the camera—likely an older friend who accompanied Babb on many of her shoots and who appears in several other photographs—must have used a tripod to achieve such remarkable clarity. But Babb has placed a hand-held box camera, an Eastman Kodak No. 2 Bulls-Eye, in the lap of the woman at far left, a clue that this scene is more orchestrated than it first appears. The direction of the women's gazes bounce the viewer from subject to subject, ending with stern Miss Merriam and the pocket watch pinned to her blouse.

Only one detail has escaped this artist's manipulations: while three of the women savor their beverages, the woman at far left has already finished hers, perhaps choosing the relief of a cool drink on a summer afternoon over the needs of a meticulous photographer.

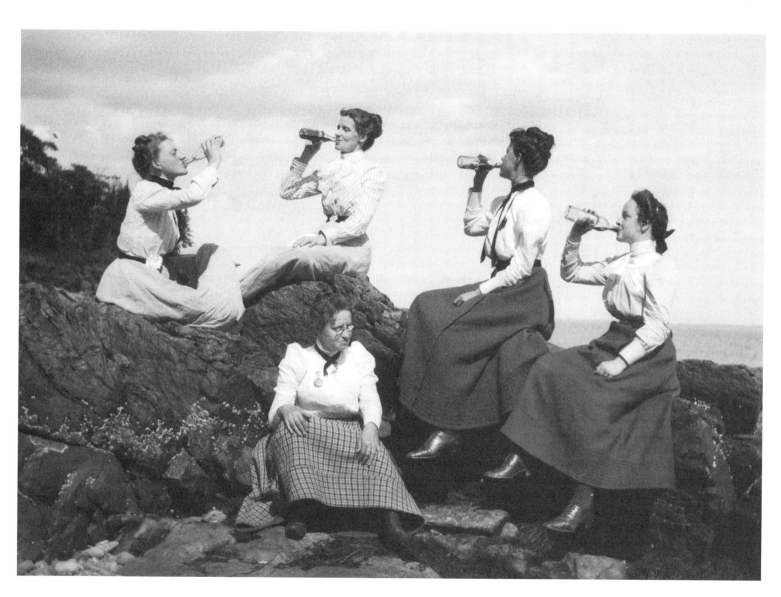

Smoking Schooner

The danger of shipping lime was brought into focus in Rockport at the turn of the twentieth century.

The battle appeared all but lost by the time an unknown cameraman took this remarkable photograph of the schooner *Onward* ablaze in Rockport Harbor at the beginning of the twentieth century. The decks are awash and the man standing at the mainmast shrouds, just left of center, is about to get his feet wet as he perches on top of the bulwarks, the smoke and steam swirling around him. Two fellows wait beside him in a dory. Judging by his posture, the man with his hands on his hips, at center, may well be the *Onward*'s owner, watching a bit of his livelihood go up in smoke. A slightly less bold crewmember observes the blaze from the base of the bowsprit, at right, as a second dory circles past the foundering ship's stern.

The most striking thing about this photograph, of course, is the utter lack of urgency it captures. Fires were common aboard the cargo schooners that carried lime from the kilns in Rockport for use as mortar and plaster in Boston and New York, as the processed lime would ignite the instant any moisture touched it. Tight wooden casks prevented most water from reaching the volatile goods, but the aged cargo schooners like the *Onward*—she was about thirty-five years old when this photo was taken—that were chosen for this service were known to let a bit of seawater aboard between their planks. Clearly this crew knew just what to do when the fire started, as unlike the moored schooner at far left, the *Onward* has been stripped of her sails, booms, and even her running rigging, shown by the blocks hanging empty at the top of the masts. The cabins have been sealed in an attempt to snuff out the flames, and an anchor hangs off the port bow, ready to deploy if the ship begins to drift near other vessels or else collides with the leaning granite dolphin post, right of center. Fires like this one were known to burn for days or even weeks, and captains sometimes simply waited out the blaze before pumping out their ships.

That strategy appears to have worked with the *Onward*. While the seventy-two-foot-long ship's final resting place is unknown, we know that it is not one of the half-dozen wrecks scattered across the bottom of Rockport Harbor, several of them less-fortunate lime schooners. But even though she might have lived to sail another day—she is listed in a 1902 register of ships but disappears from the list by 1907—the days of heavy industry in Rockport were already drawing to a close when another fire destroyed the Rockport kilns in 1907, as the demand for pure limestone had been supplanted by the advent of cement. The *Onward* won the battle recorded here, it seems, but the war was lost even before this photographer opened his shutter.

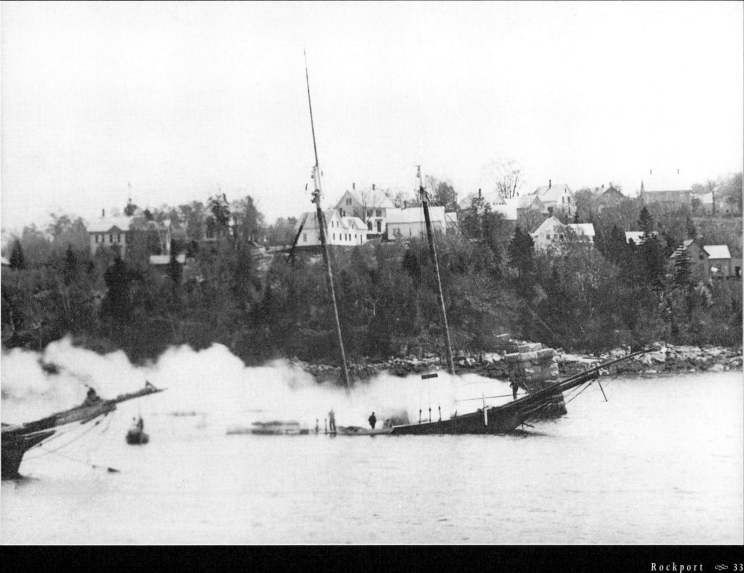

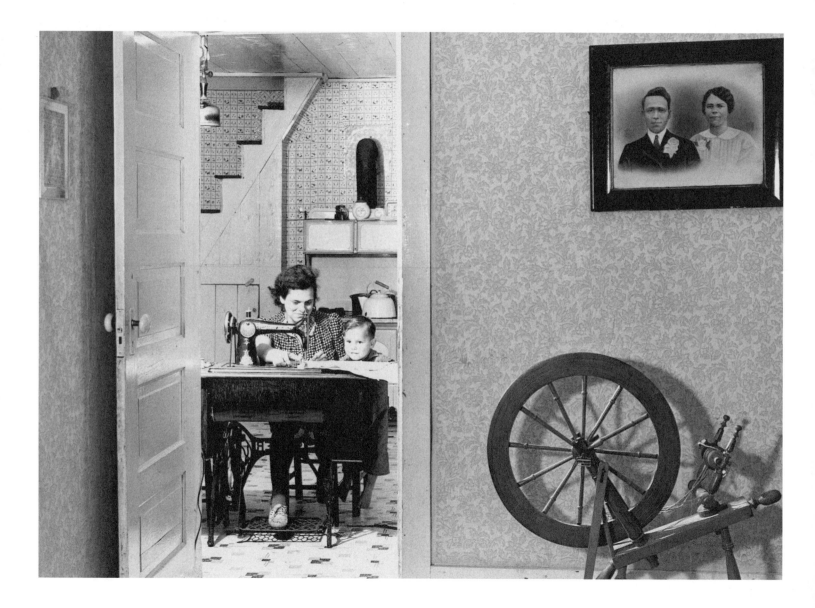

Acadian Snapshot

A tidy home and a coiffed youngster could not conceal tough times for Maine's potato farmers during the Great Depression.

Two-year-old Réal Gendreau might not have had a clue who the man from Washington was when photographer Jack Delano showed up at his family's farmhouse near Madawaska back in October 1940, but Gendreau's mother, Julie, certainly did. Mrs. Gendreau, shown here posing with Réal at the Singer sewing machine she set up in her kitchen, has made sure the tot's hair is carefully combed, the salt and pepper jars, clock, and teapot are neatly arranged upon the stove behind her, and the wedding portrait of Julie and her husband, Baptiste, hangs straight on the living room wall. For the Gendreaus, recipients of loans from the Farm Security Administration, it was essential that the visiting lensman see the potato-farming family as worthwhile and industrious. The sewing machine, for instance, proves that Mrs. Gendreau can mend the clothing worn by her eleven children. The wooden spinning wheel, at far right, indicates that she is able to turn the wool from her sheep into yarn for much-needed sweaters.

During the Great Depression, more potato-farming families in the St. John Valley received federal assistance than anywhere north of Maryland, as the federal government helped them cultivate higher quality potato seed, according to C. Stewart Doty's *Acadian Hard Times*. But farmers, including the Gendreaus, struggled to eke out a living after the FSA was abolished in 1946. Today, only about a hundred farms exist in the St. John Valley.

Even as Delano's photograph captures the pride of the Gendreau family, it also subtly conveys some of the challenges facing these rural Mainers. The door to the woodbox, at far left, indicates that this family relied on its woodstove after many other Americans had taken to more modern ranges. And while Delano has succeeded in illuminating the two rooms with the flash from his Graflex Speed Graphic camera, the kerosene lamp, at upper left, reveals that the Gendreau home operated without electricity (in fact, it would be another eight years before the power lines made it out to their hundred-acre farm). But for Réal, such struggles have always been part of life in the valley. "My older brothers and sisters remember the hard times," says the now sixty-eight-year-old Réal, who opted for a life in the clothing business rather than on the farm. "You lived off the land. Today, if you don't have a lot of acres you aren't going to survive."

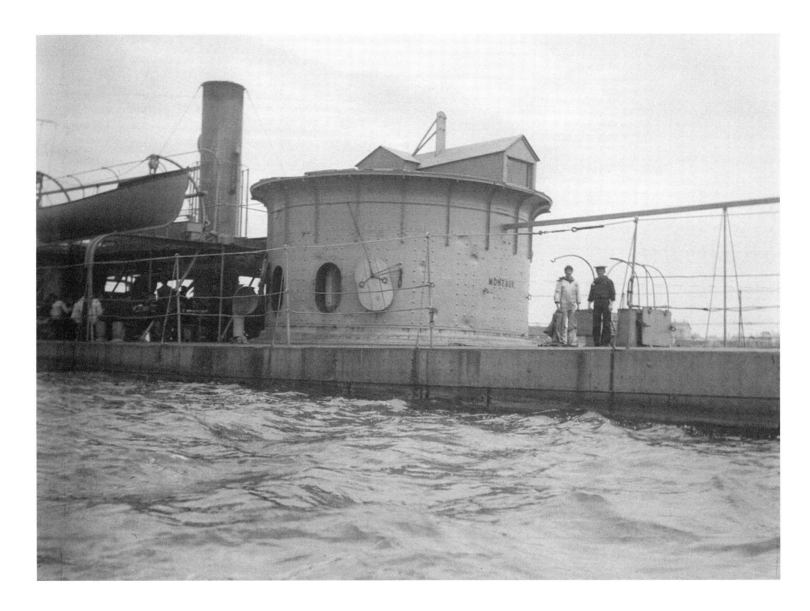

Ironclad Defense

During the Spanish-American War the U.S. Navy did indeed remember Maine.

Perhaps it was all about the name. Surely no one believed that the Spanish navy would attack Portland back in 1898, but since it was the sinking of a warship bearing the name of the Forest City's home state that had ignited the Spanish-American War in April of that year, military commanders were taking no chances. The iron-hulled, two-hundred-foot-long USS *Montauk*, photographed here by local lensman Carl C. Coffin, dropped anchor off Fort Gorges on May 13, 1898, her seventy-person crew charged with defending Maine's largest city. Less than a week after arriving, however, most of her New Jersey crew was sent home, leaving the men of the Portland Naval Reserve to draw lots for who would serve aboard the aging warship (which reportedly required near-constant pumping to keep afloat) for the next ten months.

Judging by the lifeboat still hanging in the davits, at far left, and the puzzled expressions of the two out-of-town seamen, just right of center, the Civil War–era ship had only recently arrived in Casco Bay when Coffin paid them a visit. A dozen sailors eat their salt beef and drink coffee at wooden tables set up at far left, likely enjoying the fresh Maine air after a cramped voyage belowdecks where the only air was provided by a pair of cowl vents, just left of center. The doors of the rotating riveted-iron turret have been lashed open, but the powerful eleven- and fifteen-inch Dahlgren cannons have not yet been hauled into fighting position below the miniature barn-roofed conning tower.

While the hostilities between Spain and the United States over Cuban independence resulted in the manning of several Maine coast battlements, such as Fort Gorges, most for the last time, the *Montauk*'s arrival in Maine was in some ways more historic than defensive. This warship—along with the USS *Monitor* and several other similar iron-hulled vessels—had written naval history by her persistence during Civil War sieges of places like Fort Sumter, Fort McAllister, and Fort Wagner. After the war, *Montauk* had even served as a floating platform upon which the autopsy of John Wilkes Booth was performed and as a temporary jail for his co-conspirators.

Indeed, the *Montauk*'s power by the time she arrived in Portland Harbor likely rested not in the size of her cannons or her speed through the water, but rather in what she represented to a country once again at war. Photographer Coffin seems to have understood this, having chosen to center his remarkable photograph on the round dents left on the ship's turret by Confederate cannonballs. Like her country, this proud ship has been bruised and battered in battle, but she will endure.

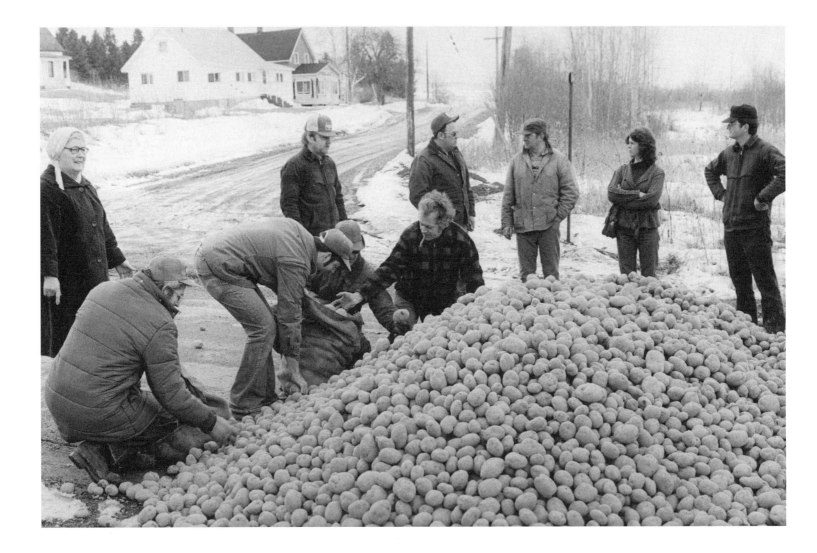

Potato Blockade

Maine farmers used spuds to make a political statement in 1980.

If there's one thing folks in The County know, it's spuds. Potatoes built northern Maine's economy acre by acre during the early twentieth century—by the 1920s Aroostook County led the United States in their production. And so, when farmers' livelihoods were threatened by imported Canadian potatoes in 1980, Maine growers turned to their signature commodity to make a point. During the dawn hours of March 27, dozens of potato farmers drove their flatbed pickup trucks to several northern Maine border crossings and dumped thousands of potatoes in the road.

The pile shown here, deposited on the Perth/Andover crossing in Fort Fairfield, is being watched over by a half-dozen Maine farmers who spent the next forty-eight hours making sure no Canadian potatoes crossed into Maine. "One trucker thought he was going to go across, but we talked him out of it," remarks Brock Good when shown this photograph for the first time, twenty-seven years after it was made. Good, standing at center with his hat kicked back, knew not to infringe upon Canada's sovereignty; he and his fellow farmers are all standing on American soil, with the Canadian border running roughly along the snowbank and curb at left. Though Larry McKenney, just left of center, wearing his trademark Bravo fungicide cap, observes the scene with a certain amount of stoicism, Dave McKenney, at far right, and the woman beside him seem to be using the blockade as an excuse to catch up with old friends.

"The Canadian growers were receiving subsidies that we weren't, and we thought it was an uneven playing field," explains Danny Labrie, who helped organize the blockade and still raises potatoes in St. Agatha. "We got together and thought of what we could do to get the attention of Washington. Potatoes were cheap and plentiful." This protest and the ones that followed the following evening, including a blockade at the I-95 crossing in Houlton, drew news photographers and led to a series of federal investigations, though no unfair trade practices were unearthed. Unfortunately for Mainers, the American potato industry never improved, as Maine saw its potato acreage decline from 108,000 acres to 61,000 at the same time that Canadian farms grew by roughly the inverse proportion.

Despite their professional disputes, of course, people in The County have never harbored a grudge toward their neighbors over the line. In this photograph, local farmer Dean Hodgkins, kneeling at center with a cigar, has actually started collecting potatoes for Mrs. Medley Hartley, at far left, whose home was located on the Canadian side. While these bold farmers proved that potatoes could be used to exert political pressure, they have not forgotten that the greater purpose of Aroostook's prize crop has always been to fill hungry stomachs.

Hot Type

Writers in turn-of-the-century Bangor did whatever it took to keep warm.

Cold Winter. Those were the words printed in faint typewriter ink on the border of this humorous photograph, which someone was kind enough to send to *Down East* recently. The identity of the bespectacled wordsmith shown here has been lost to history, but for all we know it may be Bangor photographer William H. Blacar, whose name and address are printed on the back of the image. Blacar has carefully composed this scene for maximum effect, combining the Remington Standard 2 typewriter—still somewhat of a novelty when this image was made, probably in the 1890s—and the stack of newspapers on the rack at upper right to suggest that this is the way Maine writers were forced to work during the winter.

Though Blacar was just an amateur photographer—he worked as a jeweler and engraver in his professional life, and most of his glass-plate negatives show architectural details and a few lackluster scenics—he managed to capture plenty of authentic aspects of a Bangor winter in this obviously staged shot. Many homes in the Queen City featured impressive stoves like this one, a New Clarion coal unit introduced by the Wood & Bishop Company in Bangor in 1882, according to the engraving on the ash-pan door at lower left. And when the mercury dropped, people would use the wire-handled shovel, barely visible at far left, to load the stove with coal, toss some newspaper under the burner cover that has been left askew, just left of center, and take a match from the match safe hanging at upper left and ignite it on the striker below it. Once the stove was lit, the crank resting on the stovepipe, just left of center, would be slipped onto the knob protruding between the doors of the firebox and the ash pan and turned, dumping the ashes and making room for new coal. At this point, people were known to wrap themselves in a quilt and open the oven door to warm their toes a bit (though most would have removed their scuffed shoes first!).

For all his work orchestrating this scene, however, Blacar inadvertently left one subtle clue to indicate that this chilly scribe surely did not normally do his typing here. Even in this grainy print, steam is faintly visible coming from the spout of the teapot, at left, indicating that the stove was, in fact, lit. This scene might have warmed the hearts of writers from away, but Maine authors would know that extended exposure to the stove's tremendous heat would have been far too much for the ribbon, keypads, and machinery used in this hilarious winter tableaux.

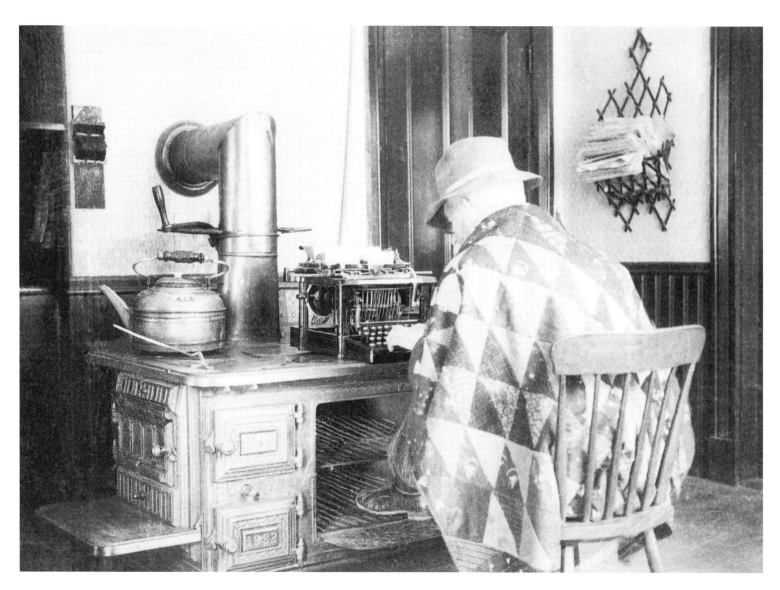

Eye of the Beholder

In 1937 a photographer in York Harbor paid tribute to the big business of beauty.

If there was anything that Florence Nightingale Graham craved, it was perfection. When her name didn't match the style of her line of beauty products, she changed it to the more highbrow-sounding Elizabeth Arden. So the cosmetics queen would no doubt have been tickled as pink as her products to see how artfully photographer Philip A. Gordon had captured them in this York Harbor drug store back in June 1937. Through natural-sounding creations such as the orange skin cream and blue grass perfume on the top shelf and the "June Geranium" soaps, bath salts, and brushes on the bottom ("A 'Thank You' gift for your hostess," according to the sign at lower right), Arden created a multi-million-dollar empire even as the Depression sent many Americans in search of soup kitchens. Her quest for perfection even took her to Maine. Just three years before shopkeeper Eleanor Fry commissioned this photograph, probably for use in her own advertising, Arden had opened a retreat she named Maine Chance Farm in the Kennebec County hamlet of Mount Vernon. Here movie stars, diplomats, and politicos could enjoy massages, mud packs, manicures, and a host of other body makeovers—all involving the trademarked beauty products pictured here.

For his part, photographer Gordon has imbued the photograph with a few personal touches that add some local color to Arden's otherwise starkly monochromatic display. In addition to capturing his own hooded image, complete with tripod and view camera, just left of center, Gordon has included the face of his flashbulb-wielding assistant, at far right. But he's also hidden some distinctly local elements, from the reflection of the postcard rack, at far left, that includes a photo of the Trinity Church just down the street, to the manufacturer's label, at lower middle, on the display case identifying it as a product of the Hermsdorf Fixtures Company in nearby Manchester, New Hampshire. Even the reflection to the right of the photographer appears to show the early summer leaves on the trees outside the store.

While Arden, who was so enamored with the Pine Tree State that she used the Maine Chance name even on her out-of-state resorts, might have enjoyed this photographer's subtle touches, she probably would have disdained one aspect of his composition. Having spent her life and made her fortune helping women improve their physical image and health, she would have looked askance at the sugar tablets, five-cent Chocolate Checkerberry Necco Wafers, and maple sugar candy that Gordon has left in the foreground of his image. Ms. Arden might not have approved, but we can't help feeling that this clever juxtaposition adds a sweet taste of reality to this advertisement of corporeal perfection.

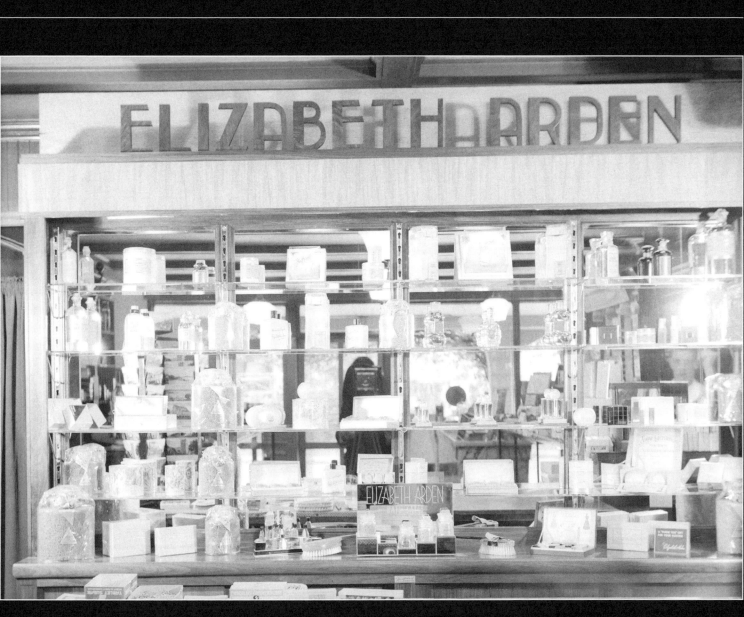

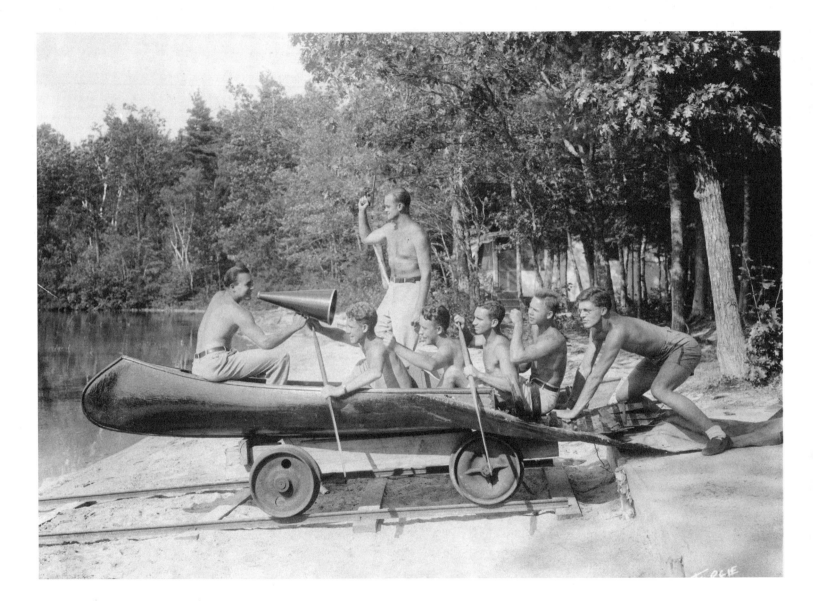

Boys Will Be Boys

A wrecked canoe makes for a hilarious end to summer at a boys camp in 1934.

Sometimes it seems there is no end to the lengths to which young men will go to have fun at Maine's summer camps, even if it means paddling half a canoe on a track to nowhere. When a tree fell on this wood-and-canvas Old Town Guide's Model in late August back in 1934, these seven counselors at Camp Ettowah on Lower Kimball Pond in Fryeburg decided the proud green ship needed a proper send-off before landing in the burn pile. A set of railroad tracks, recovered from the nearby Bridgton and Saco River Narrow Gauge Railroad and used to haul docks from the water, provided the perfect means for getting the questionable craft into the drink.

Photographer Fraser Forgie, who regularly escaped from scorching Boston summers to the cool of western Maine, was happy to capture Perry O'Dell, at left with a bullhorn; Bob "Benny" Mattoon, standing with a handgun; Carl Stevens, at right wearing spectacles; and four buddies from Wesleyan University who had spent the summer working at Ettowah. Forgie found that humorous photographs such as this one sold well among the sixty campers and their parents, all of whom apparently appreciated knowing that the counselors never took themselves too seriously.

That wasn't a problem at Ettowah, for counselors or campers. In addition to marksmanship (responsible campers might have gotten to try Mattoon's pistol, which appears to be a .22-caliber Colt Woodsman), hiking, and swimming, boys learned practical skills such as woodworking and farming at Ettowah. "During the war, with rationing it was tough to get food for sixty kids, so we raised hogs and steers and we used three acres on a farm down the road to raise vegetables," explains Andrew Holmes, whose father started Ettowah in 1927 and who ran the camp himself before selling it in 1975. Holmes says the cabin in the background of this photograph, known as the "skunk" cabin, originally belonged to his parents but, along with many other structures on the 140-acre property, was later expanded by counselors and campers.

Holmes, who like his father worked as a headmaster during the school year, says summers at Ettowah taught both counselors and campers more than any private-school curriculum could. "I believe that we did more valuable education at camp than we ever did at school," Holmes says.

Judging by the expressions on these young men's faces, the experience of spending the summer at a Maine camp was not the only thing about to sink in.

Blank Slate

Mining put the North Woods
town of Monson on the map—
in more ways than one.

When it comes to business, time is money, and therefore only a photographer employed by the Maine Slate Company of Monson could have gotten these six quarry workers to pause from their labor to pose for this chilly scene around the turn of the twentieth century. The men have placed their wooden ladder onto the snowy ledge at lower left, having already used it to reach the horizontal seam above their heads. There they affixed scaffolding to the walls and used small explosive charges and the massive pry-bars behind them to peel away in sheets the vertically striated black slate. While some pieces are small enough to hand-carry down to the bucket and cable-hoist barely visible at bottom center, others will need to be split with hammer and chisel before they can be raised up to the yard crew waiting above. This slate pit, believed to be the Burmah Quarry in west Monson, was just a few hundred feet deep, but other slate pits in the area descended more than a thousand feet and had to be prevented from collapsing by placing massive wooden cross-timbers between the walls.

Dozens of quarries were excavated in the years after Welsh immigrant William Griffith Jones discovered Monson's remarkable slate bands in 1870, as entrepreneurs hired Welshmen, Swedes, and Finnish immigrants for the backbreaking work of mining the durable material that was then turned into roofing shingles, headstones, and even ice boxes and sinks. (The fellow in the fur coat, at center, is likely a foreman or manager and looks as though he could have just arrived from Lapland.) By the time this photograph was made, the elaborate Hebron Hotel, a narrow-gauge railroad, and a community of more than 1,400 souls had sprung up around the Monson quarries. But the invention of asbestos shingles, modern refrigeration, and an increase in overseas competition would see most of the slate pits abandoned by the start of World War II.

The strength of Monson's natural resource has proven lasting, however. Today the Sheldon Slate Company, formerly the Portland-Monson Slate Company, still extracts slate from Monson and has used the stone to create such honors as the headstones of President John F. Kennedy and Jacqueline Kennedy Onassis. While the company's five-person staff now uses heavy machinery and works from open-pit mines rather than the narrow crevices shown here, it continues to produce riprap for streambeds, tiles for walkways, and kitchen countertops and sinks. "This slate really does have a national reputation for being superior to the material coming in from overseas," explains Sheldon Slate owner John Tatko, III. "I'd love to say that it's something that we do to it, but it's all a fact of Mother Nature."

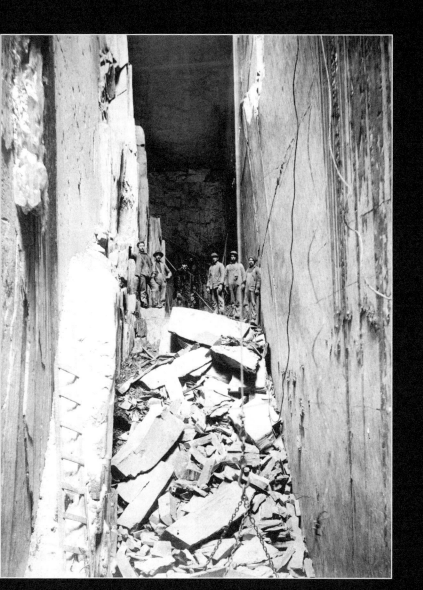

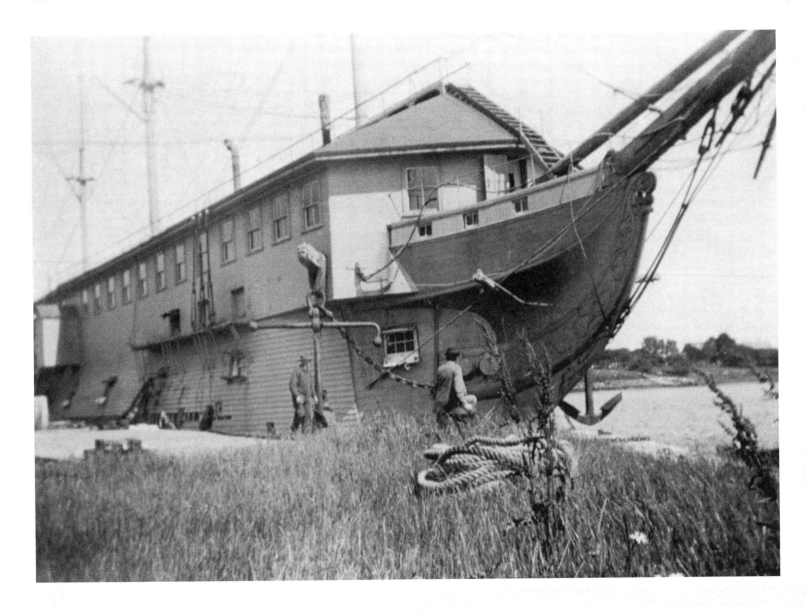

Hotel Constitution

*Maine shipbuilders helped
America's greatest ship
reclaim her dignity.*

You might not believe that this odd-looking contraption could intimidate the mightiest frigates of the British navy, but in fact the USS *Constitution* had done precisely that some eighty-five years before an unknown photographer snapped this photograph of her moored at the Portsmouth Naval Shipyard in Kittery. In the years following the War of 1812 and after scores of voyages around the world, *Constitution* had seen her spar deck covered over by a two-story barn that housed offices and a dormitory. Windowpanes instead of thundering twenty-four-pounders now fill her square cannon ports, just left of center. Her foredeck, at center, has been encapsulated to allow sailors to use the "head," or toilet, in more privacy than they might have at sea, though the vertical pipe barely visible at center may indicate that plumbing lines still drained directly into the ocean.

What is most striking about this scene is not how much has changed on board America's greatest ship by 1897 but rather how much has been preserved, even though the grand age of sail had already turned to steam and *Constitution* was little more than a floating barracks. The mizzen, main, and foremast remain standing above the barn roof, their shrouds still secured to the ship's topsides, and the spencer gaffs, at upper left, appear ready to set sails. An anchor hangs from the carved cathead, left of center, its chain feeding into the twin hawser holes. The carved billethead on the bow appears intact, and while the round jibboom above has been slid off the larger bowsprit below, the martingale stays and other standing rigging remain at the ready, as if the ship might set sail at any moment.

In fact, *Constitution* appears to be preparing for what might easily have become her last voyage when this photograph was made during the summer of 1897, as the white-oak planking, wood so tough it repelled British cannonballs and earned the ship its moniker of "Old Ironsides," has been removed, at far left, to expose her live-oak frames. Such an examination was necessary to determine if she could endure the eighteen-hour trip from Kittery to Boston, where she would eventually, after a national campaign to gather pennies as well as federal funds, be dry-docked and rebuilt. The workers at center and left, and the individuals barely visible in the dinghy at lower right, appear to be taking one last look at the ship before she departs. How pleased they would've been to know that she would return to Maine waters again, in 1931 after her restoration was complete, and that a full century later she would still be moored and open to the public in Boston, her hideous deckhouse removed and her dignity restored.

Fishy Politics

An insightful press photographer

found the real story where

no one was looking.

The best journalists know that the most telling stories often happen when the notepads have been put away and the cameras stop rolling. That's why *Casco Bay Weekly* photographer Tonee Harbert decided to keep his lens focused on the seven-pound salmon resting on the table at lower right, even after his fellow cameramen had turned their attention to Governor John "Jock" McKernan, giving a speech just out of sight to the left. The 1990 event, a presentation of the first Atlantic salmon of the year caught on the Penobscot River, was guaranteed front-page news despite the fact that the exact same ceremony had happened every year since Taft was in the White House. President George H.W. Bush dispatched Vice President Dan Quayle, at left, to listen to the speeches, shake the hand of Medway fisherman Greig Barker, standing at center with his wife, Linda, and spend a few hours raising money in the Forest City for McKernan's upcoming reelection bid.

What Harbert captured for the now-defunct *Weekly,* of course, is far more amusing than the posed photograph that ran on the front page of Maine's dailies the next day. From the strained body language of the people in the foreground—everyone, including the earpiece-wearing Secret Service agent at far left and Wildlife Commissioner Bill Vail, just right of center, has their hands crossed in the same stilted manner—to the casual off-stage conversation taking place behind them, the image conveys the behind-the-scenes banality of press events. Finally, the backdrop of Air Force Two serves as a reminder that this presidential scene is taking place in a most unlikely spot—on the tarmac at the Portland Jetport.

"It really was kind of a surreal moment. It was all this pomp and circumstance over a prominently placed dead fish," remarks Harbert. Yet that dead fish, caught by Barker six weeks earlier and frozen by biologist Randy Spencer, at far right, has captured the attention of the fisherman and his wife. Barker's expression seems to be one of pride ("I think it was closer to seven and a half pounds—it kind of grows with age," laughs Barker today), but his wife's seems somewhere between pity and boredom.

What none of the people captured in this hilarious photograph could have known is that the frozen salmon before them would be one of the last to be caught on the Penobscot. Just a few years after Harbert took this photograph, the salmon fishing season ended, the victim of a series of dams, pollution, and over-fishing. In the past couple of years, though, a new Atlantic salmon season has been held. One thing remains certain: if Atlantic salmon return to the Penobscot in serious numbers, a photograph of a dead fish will become front-page news once again.

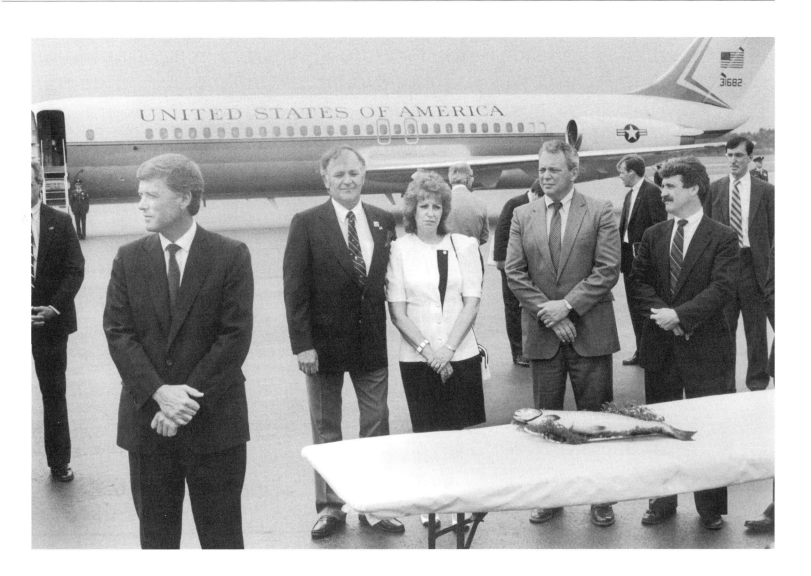

Bangor Bathers

Two young nurses helped bring a smile to the Queen City's patients during the 1920s.

W hile physicians and surgeons perform the miracles of modern medicine, it is often nurses who are charged with raising the spirits of the infirm on a daily basis. Nurses Carolyn Grant, at left, and Blanche Arnold were apparently willing to go to any length for a chuckle, even if it meant climbing into a bathtub at Bangor's Eastern Maine General Hospital back in 1927. While Arnold had been a registered nurse for a decade when this photograph was taken (most likely by a hospital employee), Grant had passed her examinations just the previous year and was already on her way to becoming a nurse supervisor of the thirty-five-year-old hospital's orthopedic department.

Grant probably used this claw-foot tub, installed in 1909 as part of the hospital's new hydro-therapeutic system, to soothe her patients' aching muscles and for their regular baths. The smaller tub on the platform at left was an adult sitz bath, with the water controlled by the single gate-valve on its right side. The cast-iron radiator at rear would've helped take the chill out of the room (though the circa-1899 brick building could hardly have been toasty in winter), while the pipe at upper right ensured that the new automatic sprinkler system remained fully charged. Such amenities were the latest developments for a hospital that began in a rented homestead but would eventually become Eastern Maine Medical Center, the largest medical facility in northern and eastern Maine. At the time Grant and Arnold posed for this photograph, the cost per patient day at the Bangor hospital was $4.78, with most patients staying for more than two weeks.

Despite the bit of silliness she's displaying here, Grant, who grew up in nearby Clifton, took her nursing duties very seriously. After marrying a resident doctor and returning with him to Nashua, New Hampshire, she became a nurse at his private practice, attended to the special needs of her own daughter for thirteen years, and served in the Red and White Cross during World War II. Family members say that despite moving across the Piscataqua River, Grant maintained a strong connection to the Pine Tree State until her death in 2004. She shared with her relatives photographs such as this one and stories of her life Down East (not to mention subscriptions to a certain Magazine of Maine). "Anything that had to do with Maine, she was interested in," says her granddaughter, Deborah Blannin.

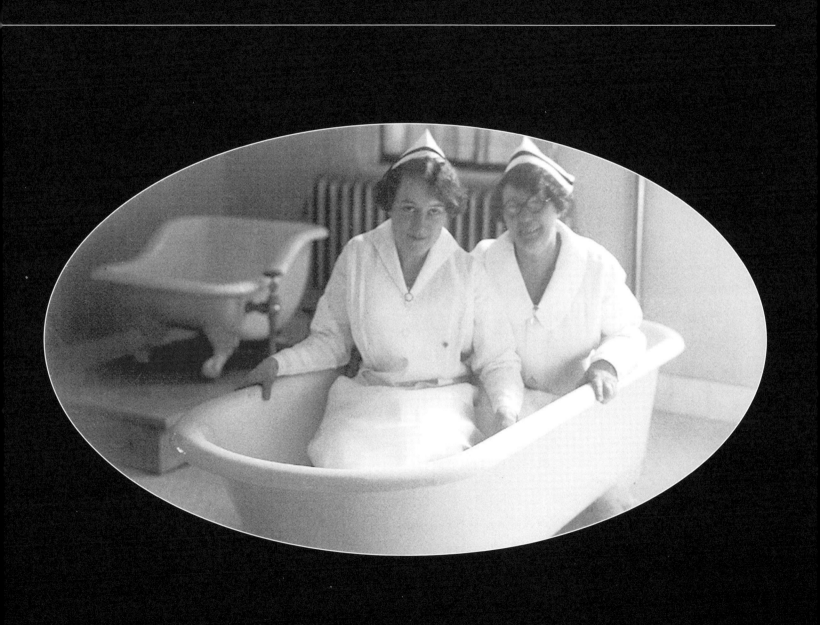

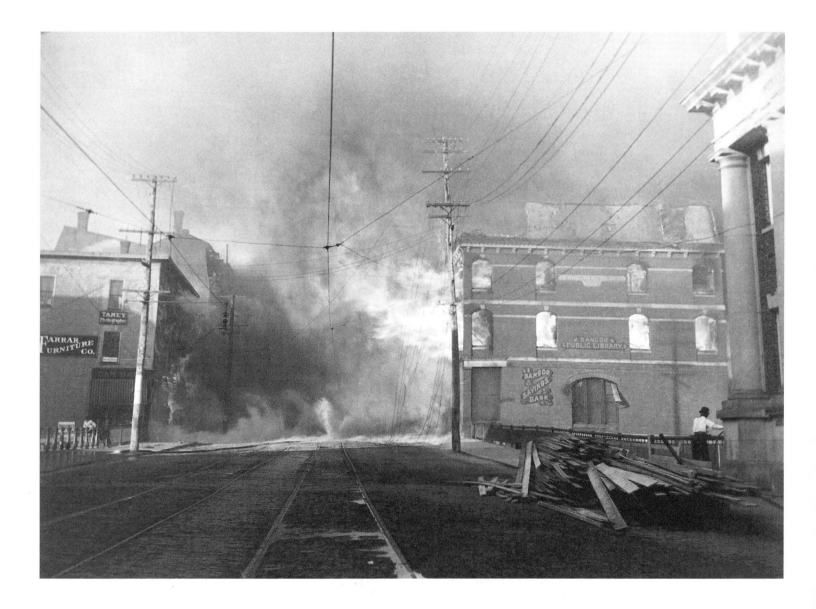

Ablaze in Bangor

A brave photographer captured a Queen City inferno back in 1911.

For photographers, fire has always represented one of the most obvious sources of drama, and the scores of blazes that leveled Maine cities around the turn of the century resulted in some impressive glass-plate negatives of burned-out hulks and smoldering ruins. But without a doubt one of the most dramatic scenes was captured on April 30, 1911, when photographer Leyland Whipple set up his tripod on Hammond Street just as the great Bangor fire was sweeping across the Kenduskeag Stream. The fire began in a hay shed a few blocks south at around 4 p.m., and judging by the length of the telephone-pole shadow on the side of the Kenduskeag Block, at right, Whipple made this image no more than a couple of hours later. The flames had already claimed the seventy thousand volumes housed within the Bangor Public Library, the largest library in the Pine Tree State at the time, and the papers of the Bangor Savings Bank on the first floor would soon be ablaze (the bank's safe would eventually be recovered from the rubble, its contents intact). Fed by a strong southerly breeze, the inferno had already ignited the wooden clapboards of the Farrar Furniture building across the street. Trolley cables and power and telephone wires had fallen onto the trolley tracks, at center, where the flames are reflected in a puddle.

Whipple managed to infuse even more action into his photograph by including the gent, at far right, who watches the fire from beside the columns of the Merrill Trust building. (The lumber in the street indicates that the bank, which escaped the blaze, was being renovated.) He has also captured the mad dash of the person at far left, who has narrowly escaped across the bridge and is ducking into the courtyard of the custom house and post office building, out of sight behind the iron barricade at far left.

Perhaps the greatest power of this image, though, is in what it conceals. The wall of flames at center hides the six-story Morse-Oliver Building just a few doors down the street; the building later collapsed and killed Brewer shoemaker John Scribner, one of only two fatalities during the fire. Smoke obscures the other buildings farther down State Street, but the awkwardly converging rooflines at upper left indicate that some buildings have already begun to implode. Even the custom house to which the runner at left flees will eventually succumb to the flames, one of some 267 buildings that would be gutted during the nine hours it took for crews from as far away as Portland to bring the fire under control. Were it not for remarkable photographs like this one, Queen City residents might never know what their city looked like on that fiery spring evening nearly a hundred years ago.

Last Portrait

The final view of this famous Maine photographer reflects upon a lifetime spent behind the lens.

For any artist, perhaps the ultimate test of bravery is to turn the lens or paintbrush upon oneself. For Chansonetta Stanley Emmons, who took this remarkable self-portrait by aiming her camera into her bedroom mirror and squeezing the shutter-release bulb in her hand, at left, this was an opportunity to depict not just who she was at that moment, but rather who she had been. Emmons had spent nearly half a century photographing rural scenes around her native Kingfield, often relying on elderly models and carefully selected settings to capture a way of life that might have belonged more to her mother's generation than her own.

Usually lugging the same 1904 Century five-by-seven-inch camera shown here, Emmons was particular to a fault when it came to her compositions, spending hours sprinkling feed so that chickens were pecking in the appropriate spot, or waiting for the sun to cast just the right shadows into a blacksmith's shop. She has been no less meticulous in composing this image, having taken advantage of geometric shapes—the arch of the mirror, at top, the angles of the tripod, at left, even the carefully arranged combs in the foreground—all perhaps presented as an homage to her father, a former schoolteacher.

Emmons, who became a widow at just forty, did not need to rely on her photography. Her brothers, F.E. and F.O. Stanley, having made their fortunes by manufacturing a dry plate photographic system and later the famed Stanley Steamer automobile, were able to support their sister both financially and by keeping her camera well stocked with negatives. Ironically, Netta, as she was known, did not return the favor by recording her siblings' inventions. Such a slight is no surprise, perhaps, as some believe she may have felt her brothers' automobiles were destroying the very history that she was recording.

In this, the last known self-portrait taken shortly before her death in 1937, Emmons, who so identified herself as a photographer that she included her camera in most self-portraits, seems to have taken advantage of several props to reflect on her own past. While her cameo brooch, at center, and glass perfume jar, at lower right, would have been perfectly appropriate for women of the time, the elaborate embroidered lace blouse she wears seems more Victorian era than Depression. Although she wears contemporary eyeglasses, she has placed in focus on the dresser a pair of pince-nez spectacles, most popular during the latter part of the nineteenth century. Like the photographer herself, it seems, this remarkable portrait has captured more than just a single moment, but rather an entire lifetime.

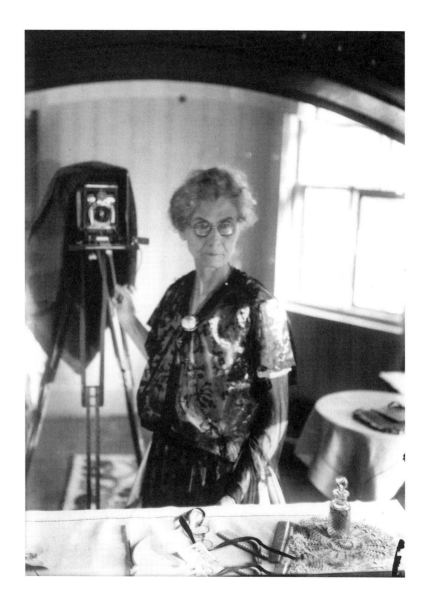

Forest City Flight

Maine's largest city was home

to an airborne winter spectacle

during the twenties.

Who needs Aspen when you have the Western Promenade? Judging by the smile on the bespectacled reporter at center and a few of the five thousand other Portlanders who braved the mid-winter chill back in 1924 to watch fearless ski-jumpers take flight, this temporary ski jump off St. John Street is the perfect venue for daredevils and bystanders alike to enjoy a most unlikely sport right in downtown Portland. Situated on top of the steep slope and with a wide-open landing zone below, the wooden jump was built by Portland ski-jump champion Birger Olsen and offered views of the Maine Central Railroad headquarters, at upper right, the frozen Fore River, and South Portland beyond. It had the added benefit of being near the still relatively new Maine General Hospital—today known as Maine Medical Center—in case any jumpers suffered more than bruised elbows and egos.

Many onlookers in this photograph have evidently arrived at this competition, a highlight of the city's annual winter carnival, on foot or by train, while others have come in the Model T Fords visible just above the center of this striking image. They have been drawn not just by the aerial display captured here, but also by skating, cross-country skiing, and dogsled races that were being held in conjunction with the festival. In an ongoing battle to prove the superiority of Portland's carnival over Augusta's, organizers that year had gone so far as to name a king and queen, a proud couple who strutted about the city in their crowns and ermine-trimmed robes.

But the real celebrities of this day most certainly were not the royalty but rather the leather-booted ski-jumpers such as the one shown here, his loose-fitting jacket billowing as he launches into the icy air. This brave athlete may have been Olsen himself, or perhaps Erling Anderson, who recorded one of the longest jumps of the day. But other, more unlikely skiers also launched themselves from the jump: eleven-year-old Clarence Olsen, whose performance impressed athletes three times his age, and fifteen-year-old Margaret Towne, whose white woolen suit and courageous leaps turned the heads of everyone assembled.

Interest in this remarkable event was so great, in fact, that the biggest obstacle for the ski jumpers was not frostbite or gravity, but the spectators themselves. A few have sought a better vantage point by climbing into the branches of the elm tree at the base of the jump, but most strain against the lines separating them from the landing zone, kept back only by the watchful eyes of carnival officials. According to the newspaper accounts, though, no one actually was hit by any of the jumpers.

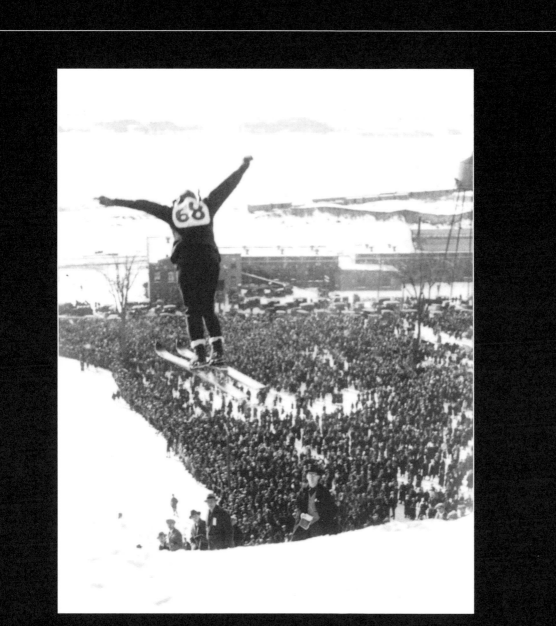

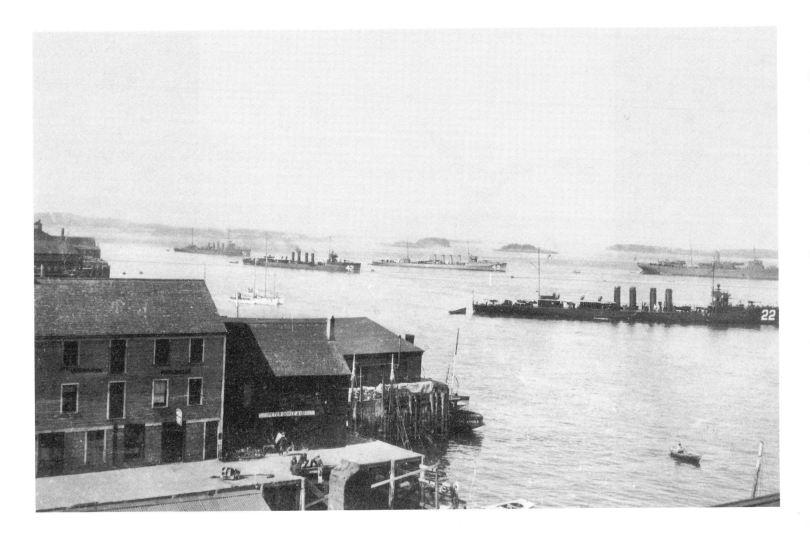

Down East Flotilla

A fleet of warships attracted surprisingly little attention in Eastport in 1916.

The tide was rising in Eastport in late June 1916 when an unknown photographer clambered onto a roof to capture this historic photograph of four U.S. Navy destroyers and a support ship at anchor between the town's north end and the Canadian outposts of, from right, Campobello, Cherry, Marble, and Indian islands. Then-Secretary of the Navy and Campobello summer resident Franklin D. Roosevelt had amassed this flotilla, including eighteen other warships not visible, to study the chances of using the harbor and its dramatic twenty-two-foot tides as a training ground for deployment to a port with similar conditions in Scotland, where Allied naval forces had begun assembling in response to the escalating conflict in Europe.

These modern coal- or oil-powered, steel-hull fighting ships seem like giant invaders juxtaposed with three rafted sardine-fishing sloops, just left of center. But for several of these warships the return to Maine waters was actually a homecoming, as they had slipped down the ways at Bath Iron Works only a few years earlier. Their imposing presence seems to have had little impact on the people of Eastport, however, as the fishermen sitting on the wharf near the bottom of the photograph appear to be casually recounting the same tall tales they've probably spun for years, and the gent rowing the peapod dory at lower right pays little attention to the menacing visitors. Even the much-loved tugboat *Mary Arnold* looks content tucked alongside nets drying on the pilings just below the center of the image.

Sailors such as the one striding in his dress whites beside the second smokestack of the U.S.S. *Paulding* (#22) would have been disappointed to know that their relaxing Down East excursion would soon be cut short. Only four days after arriving, the flotilla was sent south to discourage Pancho Villa's incursions into Texas and New Mexico. Just three months after this photograph was taken, the U.S.S. *Benham*, center, rescued the crew of a steamship sunk off Nantucket by a German submarine, while the U.S.S. *Melville*, the support ship at far right, was deployed to serve as the flagship of the commander of U.S. naval forces in Europe when the United States entered World War I the following April.

But on this pleasant early summer afternoon, the impending horrors of the Great War seem to be far from anyone's mind in Eastport—although the winds of patriotism are perhaps blowing, as the young man just left of center proudly marches in front of Peter Doyle's wharfside shop with a flag flying over his right shoulder. For the moment, at least, these great warships and the local citizenry seem to be at peace in Eastport, where the pace is set more by the changing of the tide than by global politics an ocean away.

Whistle-Stop Smile

A portrait taken in Livermore Falls evokes the era of railroad vacations in Maine.

Sometimes enjoying summer in Maine is about knowing the right people. For haberdasher Leonard D. Alger, shown here waiting at the Strickland's Ferry train station, that meant keeping in touch with Livermore native Silas R. Morse, who took this photograph around 1900. A school administrator who had invested wisely while living in Atlantic City, New Jersey, Morse would occasionally bring friends such as Alger back with him to Livermore during the summer months. While his out-of-town guests relaxed at his home and at his camps in Leeds and Rangeley, Morse passed the time by photographing the area, creating about 300 glass-plate negatives that form the largest pictorial record of this northern tip of Androscoggin County.

"This fellow looks like he might've come right off the Monopoly board, but in some ways Morse himself did," explains Dennis Stires, a Livermore historian. "He moved to New Jersey during the early Civil War, but he'd come home in the summers and take photographs here—he had the money to do it."

The composition of this image attests to Morse's expertise. The converging lines created by the gutters and roofline, at far left, and the fencepost and tracks, at right, all lead our eyes to Mr. Alger's distinctive smile. His black bowler hat contrasts perfectly with the sky above him and with the more working-class caps worn by the men positioned at left. The kerosene lamp, at upper left, angled surfaces of the wooden baggage cart, and even the stub of a cigar, barely visible in the man's hand at lower left, all return us ever so subtly to this jolly gent from away.

Life was not always so uncomplicated in this rural corner of Maine, where the mighty Androscoggin River flows through many communities. During the first half of the nineteenth century several hand-powered ferries, including one that bore the same name as the platform shown here, helped unite Livermore's residents during summer, fall, and winter. But during spring floods, when town meetings were held, the crossing often proved impossible, a harsh reality that led to the separation of Livermore and East Livermore in 1844.

But for this dapper visitor and his photographer friend, such divisions were simply part of the landscape they had come to adore, a fact of life that, along with ferry crossings and rural train stops, were all part of a summer vacation in Maine.

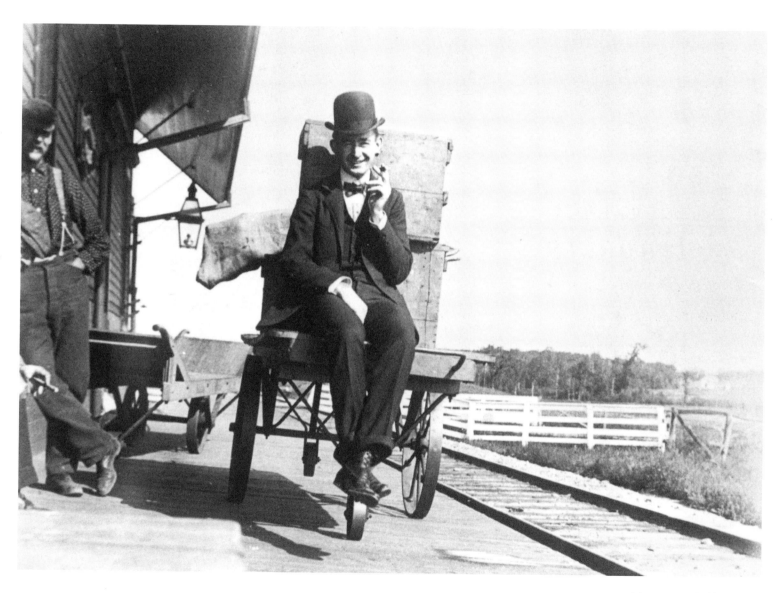

Tree Huggers

In 1961 sorority sisters at UMaine Orono put a new twist on the cramming craze.

Who needs telephone booths? Certainly not these Pi Beta Phi sorority sisters at the University of Maine in Orono, who decided to put a markedly Maine twist on the phone-booth-cramming craze back in November 1961. Having realized that such a competition might draw attention to their sisterhood—a South African record of twenty-five people in a single phone booth had sparked a whole new sort of cramming at universities in the U.S. just a few years earlier—these nimble young ladies chose a stately old hollow tree as the site for a challenge with the brothers of the Lambda Chi Alpha fraternity.

After stacking their sneakers and slippers at left, the women climbed on each other's shoulders and backs to fill the inside of the great tree, which appears to be an eastern cottonwood that had been hollow for many years and yet retained its strength (the tree at right, with its obvious burn marks, may not be so fortunate). Eight young ladies had made their way into the tree by the time an unknown photographer snapped this striking photograph, and already the women appear poised to spill out of the bottom, forcing the two women at lower center to grimace as they brace themselves while supporting the human pyramid. Thirteen Pi Phi sisters would eventually squeeze into the tree before gravity took its toll, an impressive feat topped only by the fifteen Lambda Chi brothers who succeeded them.

But for many UMO students, this unusual tree, tucked in a wood near Hancock Hall, was special for more than its ability to contain coeds. Along with two of Old Ironside's cannons mounted nearby, it had become a popular meeting spot for young men and women wishing to escape the oversight of their dorm leaders. "It was just such a romantic place," recalls Nancy Dysart, herself a sorority sister during the 1960s. "The way you could stand completely inside that tree—there was no other place like it." Many fraternity brothers even used the spot to express their commitment to their girls by "pinning" their fraternity pins on them here.

Happily, this remarkable photograph is not the only remembrance of this storied arbor. Instead of sending the great tree to the chipper when it was finally cut down in the late 1980s, university officials memorialized some of the joyful unions made here by packaging pieces of the tree and providing them to alumni. Poke around in some of the closets and on the mantels of a few Maine homes today and you'll find a piece of wood and bark that, like this photograph, tells a touching story.

Duck
and Cover

Attending school in Rockport

during the Cold War was not as

terrifying as it might seem.

Air raid! At least that's what photographer Carroll Thayer Berry wanted these thirteen Rockport schoolchildren to imagine when he asked them to pose for him back on May 2, 1952. The Cold War was getting into full swing, and these students were studiously following the advice of programs like "Operation Alert," the federal education program that advised children to "duck and cover" in the event of an atomic blast. The six boys on the right are displaying excellent form, their hands clutched tightly over their necks, and several of them even go so far as to lay face-down in the dirt where just moments earlier they might have played hopscotch or rolled marbles. The three girls and the teacher on the left of the stairs have chosen somewhat more demure positions. The severity of the drill seems to have been lost on just one child; the boy on the left side of the stairs is taking the opportunity to catch up on a last-minute reading assignment.

Berry, having become a master of the woodcut during the 1930s and 1940s, had only begun practicing black-and-white photography a few years before capturing this arresting image, one in a series of photographs of Civil Defense drills that he took in Camden and Rockport during the early 1950s. His timing could not have been more perfect: within just a few years this school, with its peeling wooden clapboards, at right, and massive clocktower with a view overlooking Penobscot Bay, would be closed as Rockport and its busier neighbor to the north consolidated their high schools into a modern high school in Camden. The impressive structure shown here went into a steady decline shortly after Berry made his photograph, nearly falling derelict before being purchased less than a decade ago by a group of neighbors who have since restored it, replacing the classrooms with offices and apartments and repairing the once-proud clock and bell.

But judging by at least one recumbent participant on this warm day more than fifty years ago, photographer Berry seems to have succeeded in convincing his young models of the importance of this atomic drill. The boy at far right, his crisp shirt likely white no longer after being pressed into the dirt, uses his arm to restrain a black dog who has joined this surreal scene. Perhaps this is fourth-grade teacher Veda Achorn's own setter, Pal, who often followed his master to school, and this clever student may just be considering feeding his own home-work to the obliging pup. Even a midday attack—or at least the charade of one—was not enough, it seems, to discourage these Maine students from their schoolyard antics on this pleasant day more than half a century ago.

Hurricane Hole

Back in 1954 railroad workers

wondered where the ground went.

etter call the dozers. That's what railroad foreman John Swallow, at top, second from left, was likely thinking while he stood more than two stories up in the air on a set of railroad tracks west of Houlton. The rails and their rough-sawn cedar ties had been suspended in midair after a stone culvert and the track's dirt underpinnings were neatly cleaved off by Hurricane Edna back in the fall of 1954. "That was a wild night," recalls Richard Sprague, the former Bangor & Aroostook Railroad employee who took this striking photograph near the tiny hamlet of Ludlow. "The destruction was unbelievable." While the storm's seventy-four-mile-per-hour winds brought down more than a few trees and power lines, the real damage came from pounding rains. Cars, roads, and even houses were swept away by brooks and streams that, already saturated by the passing of Hurricane Carol just ten days earlier, quickly became raging torrents. Most trains halted in protected areas during the storm, but one, the northbound No. 7 passenger train, hit a washout near Van Buren and overturned its locomotive, stranding passengers for the night but injuring none. Together, the two hurricanes caused $17 million in damage and resulted in eleven deaths in Maine.

Luckily for Mainers, brushes with storms such as Edna and Carol are relatively rare. The last hurricane to hit the Pine Tree State was Bob in 1991, its ninety-mile-per-hour winds lashing the coast and causing $26 million in damage. But those Mainers who might become lackadaisical during hurricane season—most storms strike between late August and early October—should heed the warnings of the National Weather Service forecasters in Gray, who estimate that severe tropical storms visit Maine about every five years, with a hurricane impacting the state about every twenty years.

But as dramatic as this scene appears, those who witnessed it firsthand say repairing the damage was all in a day's work for these nine proud railroad workers. While bulldozers and a steam shovel were indeed required to install a new steel culvert and to backfill the dirt that Hurricane Edna had swept away, photographer Sprague says the reconstruction project, which took a couple of weeks, involved mostly "brute strength, and heavy on the ingenuity." While this photograph captures the awesome power of nature, Mainers' ability to rebuild in the face of such destruction more than fifty years ago was no less impressive.

Cash and Carry

Houlton farmers helped airmen

walk the lines of neutrality

shortly before World War II.

Arnold Peabody knew firsthand that folks in northern Maine sometimes have to wear a few different hats to make ends meet. He supplemented the income from his farm equipment company in Houlton by harvesting a hundred acres of potatoes. In later years he would even make the two-hundred-mile commute to Augusta while serving as a Maine senator. So Peabody, shown seated on a John Deere tractor in this dramatic snapshot taken in 1940, was more than happy to oblige when the folks at the Houlton airfield asked him to tow a biplane across the Canadian border. Seeking to avoid war with Germany, Congress had passed the Neutrality Acts in the 1930s, prohibiting the country from trading arms with nations at war. But after the Nazis attacked Poland, Franklin Delano Roosevelt found a way around the spirit of those laws by implementing Cash and Carry revisions in 1939. They allowed American warplanes to be flown to Houlton and then hauled overland to a rudimentary airstrip in Richmond, two miles into Canada. Once in Canada, the planes flew to waiting Allied transport ships in Nova Scotia before departing for the war overseas.

The Curtiss "Helldiver" scout bomber captured here, judging by its camouflage paint scheme, painted rotor stripes, and the circular insignia barely visible on the underside of the wing at far left, was one of several that were flown from the Curtiss-Wright Corporation's factory in Buffalo, New York, to Houlton en route to a spot in the French air force. The hint of a gunsight from one of its two machine guns pokes from above the cockpit, at left, and the exterior fuel tank hanging between the retractable wheels helped the plane fulfill its one thousand-mile range. While Peabody's assistant, just left of center, manages a tether, the bearded fellow at far left seems so out of place that he might well be the pilot. These airmen didn't tarry long in Maine; a customs agent could inspect a plane in just four minutes and Peabody would be headed across the "slash"—the twenty-foot-wide section of cleared earth that even today marks the international border—in little more than ten.

The need for this ingenious diplomatic loophole was rendered null, of course, by the attack on Pearl Harbor. The air base would go on to become a POW camp, and Arnold Peabody would return to using his farm equipment for more pastoral pursuits. Perhaps most ironically, the impressive aircraft shown here would not actually make it across the Atlantic in time to save France, instead rusting in wait on the Caribbean island of Martinique.

Colossal Craft

A unique vantage point captured the scale of the largest wooden sailing ship ever built.

Rockland native Walter Snow and his brother, Maurice, took advantage of a Sunday pause in their apprenticeship at Bath Iron Works in late 1909 to capture this rare view of the seemingly endless white-pine deck of the largest wooden sailing ship ever built. She is the 329-foot, six-masted schooner *Wyoming* under construction on the ways at the Percy & Small Shipyard in Bath. Photographer Walter Snow, standing just to the right of the base of the forward-most mast, conveys the vessel's immensity by capturing the tiny figure of Maurice, at center, as he stands at the ship's stern, apparently surveying the route *Wyoming* will take when she slides into the Kennebec River in just a few weeks. From the disarray on deck—the pulley, clamps, and wooden bucket atop the deckhouse in the foreground—it would seem the 150 workers building this behemoth cargo schooner stopped in mid-stride at the first chimes of the Saturday quitting bell. Perhaps most unusual in the image is the view of the large angled timber at far right. Known as a sheer leg, it was used to install the foremast, seemingly just the day before this photo was taken. Stacked wooden hoops await six of the twenty-two sails that will be raised by lines passed around the drum of the coal-fired donkey engine protruding from the side of the deckhouse in the foreground.

In *Wyoming* the crew at Percy & Small Shipyard created the most sophisticated cargo schooner afloat, and she quickly earned a reputation for her speed and ability to carry huge loads of coal, once venturing as far as Europe. But by the time *Wyoming* was launched, the age of the wooden schooners was already drawing to a close, and she was soon eclipsed by steam-powered vessels.

Fourteen years after this photograph was made, Captain Charles Glaesel anchored *Wyoming* north of Nantucket during a March blizzard. But sometime that night tragedy hit, and the great ship disappeared beneath the Atlantic swells—theories include her being struck and sunk by a barge, or being split in two by the force of the storm. The mystery of *Wyoming*'s demise may soon be solved, however, as recently an underwater survey team located her remains. Hopefully a few pieces of the grand schooner will be returned to her birthplace, now the Maine Maritime Museum in Bath.

Walter Snow captured a rare moment of tranquility when he made this photograph, but even on a Sunday he could not escape the curious onlookers who came to marvel; a figure slips over the port rail, just right of center, one of the many who had to have a look at the massive schooner.

A Perfect Pose

Maine's seaweed-covered coast made for an unlikely perch for this early ballerina.

Ah, the fabled coast of Maine in summer. The photographer who convinced this unidentified dancer to strike a pose on seaweed-covered rocks in the Cape Neddick River around 1917 appears to have had one goal: to portray the massive, multiturreted Passaconaway Inn, at center, as a remote, but still civilized, seaside resort. The dancer's distinctive long ringlets, circa-1915 headband, and knee-length tunic help draw observers' eyes away from the dozens of homes that had begun popping up around the prestigious 175-room summer resort in Cape Neddick's York Cliffs subdivision. Eager vacationers-to-be who saw this image—a lantern slide that the inn almost surely commissioned and used as an advertisement—might even mistake the electric pole in the distance behind the dancer for the mast of a ship passing on the open ocean beyond the inn. The dancer's posture is both classic and practical, eminently graceful but also furthering the illusion of isolation by almost completely hiding the roofline of a house behind her left leg. But the photographer still needed some natural help to make his deception complete, using shadows to obscure a boarded-up cottage on the hillside just below the inn, and the boathouses on the river's edge, at far left. While he couldn't keep the imposing house at left out of his artful photograph, his careful cropping has completely eliminated the sands of Cape Neddick Beach, just left of where he captured this pleasing image.

But the Passaconaway hardly needed this photographer's careful composition to market itself. Designed by local architect E.B. Blaisdell and built during a record-setting ninety-day blitz in 1892, it boasted steam heat throughout, marble countertops and a fireplace in every room, plus an eighteen-hole golf course, bowling alley, tennis courts, and, perhaps most noteworthy for a resort at the time, a fire-proof garage and automobile livery. Vacationers seeking to shake off the economic recession of the early 1890s arrived via one of the four railway connections that had begun making daily stops in York in 1887, a time when the town saw its valuation and corresponding number of hotels double within a single decade.

This graceful dancer could have no idea that just twenty years after her pose was captured, the Passaconaway's turrets, friezes, and balconies would come crashing down, as the grand inn was demolished in 1937 after the Depression consumed the vacation budgets that funded it.

But on this perfect day where even the clouds seem to have cooperated, this dancer's contented expression may change when she discovers the one detail that her photographer failed to address; when she puts her bare foot down and attempts to leave her perch, she will surely learn why so few ballerinas perform on Maine's barnacled shores.

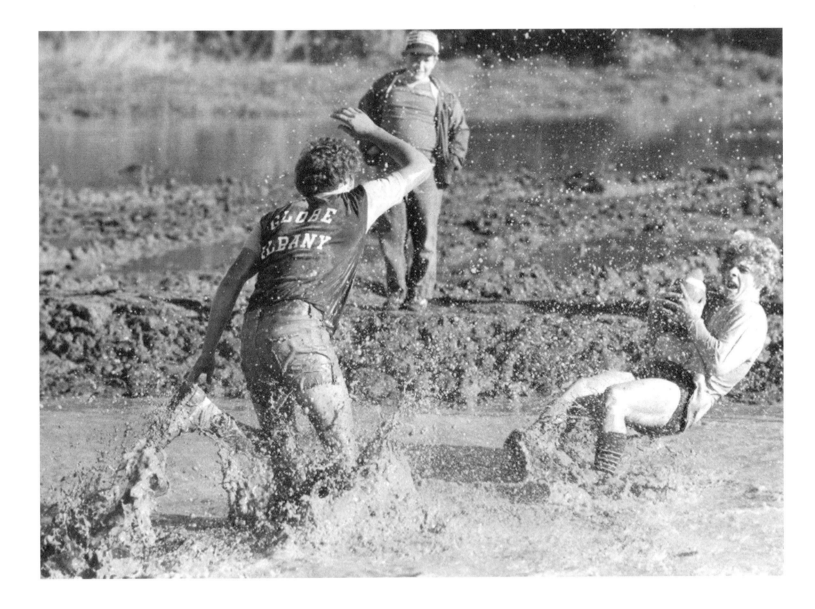

Sunday
Muddy
Sunday

A slip in the Kingfield mud was all in the name of charity and fun back in 1981.

Is Reggie Conrad, at far right, grimacing because he knows he's about to be pummeled by a gridiron opponent from the Empire State, or because he realizes his blond curls are about to get a mud bath? Perhaps a bit of both, but the amused expression on the youngster at center indicates that likely no one was taking this mud football game in the Carrabassett Valley too seriously. Conceived by a group of fraternity brothers from the University of Maine who had moved to Sugarloaf after graduation, the game evolved into a sloppy fundraiser for local charities. "It started just as an excuse to bang heads, drink beers, and not give up our youth," explains David Cianciolo, who played mud football during the 1970s. "Then it just snowballed because it raised money for charity and we could keep getting away with it."

Thanks in part to an appearance on the television program *Real People* in 1981, the competition that typically raised only a few hundred dollars brought in more than $25,000 the following year. A series of regional mudbowls developed, with the national mudbowl championship—now held every September in a "hog coliseum" in North Conway, New Hampshire—hauling in a whopping $450,000 over the years for charity.

But mud football hasn't forgotten its slippery roots. Every year games are held across New England, including a series in Kingfield. College football players, local strongmen, and even a pro baller or two will rototill a field beside the Carrabassett River, the local fire department will flood it, and the slippin' and slidin' begins. The games are characterized as "firm two-hand touch," but competitors say that when bragging rights are on the line, even Tom Brady would have a tough time dodging their blitz. And while the fashions have changed since *Kennebec Journal* photographer Jay Reiter captured Conrad's slide—the cutoff jeans shown here have been replaced by Lycra—the spirit of the event and the festivities surrounding it remain the same. The "whatever" boat race still finds the same flimsy, homemade crafts floating down the Carrabassett River, live music still rings forth from the center of town, and Miss Kingfield still receives her crown at the height of the festivities.

But beauty queens and brass bands were probably not on Reggie Conrad's mind when he fielded this pass for his team, the Razorbacks, and slipped into the Kingfield muck. Judging by his expression, Conrad appears more concerned with maintaining possession of the football—and a touch of composure—as he goes hog wild during a Maine summer.

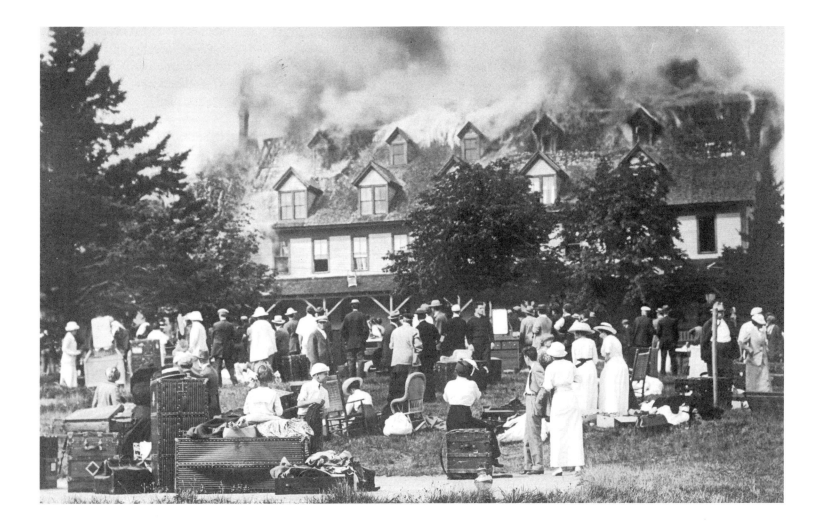

Hotel Inferno

A devastating Southport fire made for an unlikely lawn party in 1913.

The scene that Boothbay photographers Frank McDougall and William J. Keefe witnessed when they stepped onto Mouse Island in Southport one fine August day in 1913 seemed impossible. The Samoset, a grand hotel accommodating up to 125 guests, many of them writers and artists seeking respite from the hustle-and-bustle and sweltering heat of Boston and New York, was engulfed in flames. From the way smoke is billowing from the roof in this photograph, the domestic water system that Samoset owner Keys H. Richards had installed and which his own advertising boasted gave guests "a positive guarantee of water for all purposes, including a possible fire" appears to have done little to slow the blaze, and the lack of a bridge to Southport Island has prevented any neighboring fire departments from reaching the hotel. As horrific as this fire was, such conflagrations were relatively common during this period; just two months earlier the grand Menawarmet Hotel in nearby Boothbay Harbor had gone up in smoke.

Indeed, the historic image that McDougall and Keefe captured suggests that the Samoset's staff had learned from these other devastating fires: judging by the number of steamer trunks and wicker chairs that are arrayed on the Samoset's expansive lawn, they must have begun emptying the resort at the first whiff of smoke. (A few pieces of furniture, including the overturned chair on the porch roof just left of center, failed to make the entire journey to safety, but remarkably several dressers and their mirrors, including the one right of center, remain intact.)

But this quick-spreading fire, which reportedly started in the thirty-six-year-old hotel's kitchen, gave guests little time to pack, and at least one vacationer has evidently grabbed a single drawer, at lower left, as a makeshift suitcase. It also appears that someone broke out the second-floor window at far right, perhaps to save belongings. A few onlookers, like the young lad left of center, have already begun folding their family's clothing, even as others, including the man just right of center, can only stand numbly with their hands in their pockets and watch as their possessions—and likely the rest of their vacation—are consumed by the flames. Most guests, including the women leaning on a dresser just left of center, are focused on last-minute salvage work underway at the left side of the building—likely near the fire's origin, since the roof there has already collapsed—but not everyone is idle; two men are faintly visible, at far right, still ferrying furniture and belongings from the burning building.

From the clothing all the guests are wearing it is apparent that vacationing at a Maine resort hotel had a very different tone nearly a century ago—all but three of the fifty observers are wearing hats. The Samoset is lost, it seems, but dignity and decorum still prevail.

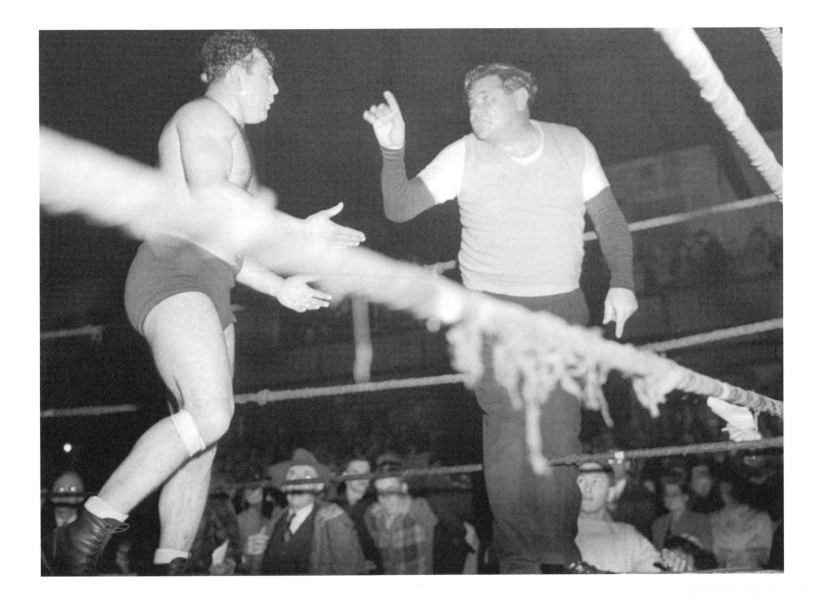

Wrestling with the Babe

The great slugger traded the diamond for a Portland ring back in 1945.

Don't even think about taking a swipe at the Sultan of Swat. That's the message home-run-king-turned-referee George Herman "Babe" Ruth, at right, is sending to professional wrestler Manuel Cortez in this remarkable photograph taken during a match at the Portland Expo back in 1945. According to an account in the *Lowell Sun*, Cortez had been overly rough with his opponent, Seattle's Leo Numa, from the opening bell during a match in front of 2,300 excited Portlanders, and referee Ruth had to warn him repeatedly against unnecessary roughness. And while the bare-chested, 200-pound Cortez might have intimidated some officials, the fifty-one-year-old Bambino, who has climbed in and straddles the tattered lower ropes, shows no fear in raising his finger to the Mexican grappler. Such antics were all part of the show, of course, for the many Mainers such as the youngsters in the plaid shirts, just left of center, who reportedly howled and screamed advice to the rookie referee. (Such interaction with the crowd, Ruth told sportswriters of the time, was what attracted him to wrestling in the first place.)

Ruth's gentle show of force apparently proved insufficient to subdue this agitated athlete, however, as just moments later Cortez—who the Babe finally disqualified for his rough play—threatened to punch him. Despite being drenched in sweat (dressed in trousers and a long-sleeved shirt, Ruth estimated that he must have lost four pounds during the bout), the Babe responded by cocking his left fist and "roared mightily" at the wrestler, who soon thought better of his violent response.

As unusual as this scene appears, America's favorite slugger was no stranger to the ring—or to Maine—by the time this photograph was taken. Before the Red Sox incurred the infamous (and now proudly broken) curse that bore his nickname, the Bambino served in various roles at boxing and wrestling matches, all the while building a record lifetime slugging percentage that still stands. He was also a frequent visitor to the Pemaquid Peninsula during the 1920s and 30s, and baseballs bearing the legend's trademark "The Babe" autograph still adorn the mantels of a few lucky homes there.

But baseball was not on the minds of the Mainers gathered on this warm evening in Portland more than sixty years ago. Instead these spectators, from the dapper gents in suits and ties, at lower left, to even a few members of Portland's fairer sex, at lower right, have all come to observe a spectacle in the ring. They have gathered, no doubt, to marvel as much at the Bambino's performance as that of the grapplers, and the violent charade that the Babe offered here, like his legendary prowess at the plate, certainly did not disappoint.

Leap of Faith

Downtown York was the setting

for a daring prewar drill.

It would seem that the good people of York have lost all sense of propriety and compassion, flocking as they have to watch what must surely be a lunatic, or at the very least a reckless daredevil in his full-length overcoat and hat, leap from a second-floor window of the York Realty Building in York Village on a bright, chilly autumn day. Worse still, the uniformed gent watching from the upper window is grinning, and the women bundled in their overcoats, at far left, seem to share his glee at watching this drama unfold. Luckily for them—as well as for the brave York gentleman who, having climbed the wooden ladder at center and launched himself into the air, will soon be caught in the outstretched net held by his fellow local firefighters below—this aerial display is a perfectly orchestrated Civil Defense League drill. It was one of many such exercises that were held in the early 1940s as local residents practiced how to respond if the war in Europe spread across the Atlantic.

By the time local photographer Philip A. Gordon composed this masterful image (notice how the wooden ladder, the roofline of the adjacent building, and the crowd's gaze all focus attention on the jumper), traffic on Main Street has come to a halt and the crowd observing the drama has swollen to include several gray-haired Civil Defense officers, at lower right, and dozens of smartly dressed men and women who have come out of the First National supermarket and the Cumberland County Power and Light Company office, at far left. The commotion has even lured diners away from the soda fountain and into the window of Dr. Hawkes' Pharmacy, just right of center, but only the balding, white-coated proprietor has ventured out into the brisk, late fall afternoon to observe the display.

Presumably the children of York were all in school and all the able-bodied young men were already in uniform abroad or maybe they were off manning the lookout tower on nearby Mount Agamenticus when photographer Gordon captured this fireman's remarkable jump. The only military-age people visible in this photograph are the conspicuously underdressed fellow in plaid flannel at left and the small group of youngsters standing in the York Realty doorway, at upper right. But these are hardly slackers. Even on this pleasant afternoon at least one boy, at far right, has come prepared to defend his hometown, wielding a rifle as if that might be a Nazi jumping out the window in the middle of York.

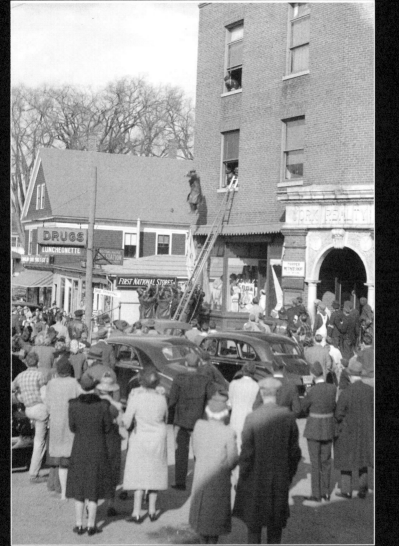

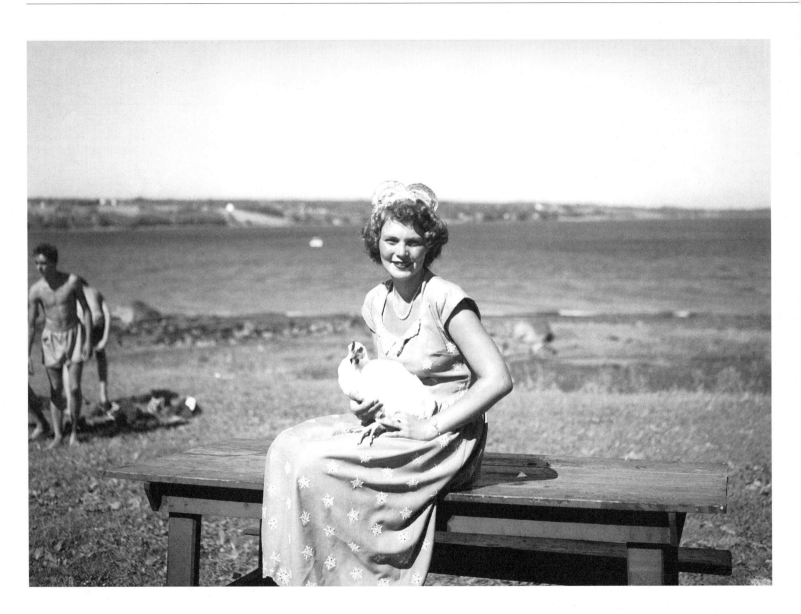

Hail to the Queen

One of Maine's biggest industries hatched a popular summer festival back in the 1940s.

You know it's summer in Maine when young men like the ones at far left begin braving a dip in the bay and young ladies like Miss Betty Perry, shown here, bring out their pearls, sequined tiaras—and livestock. At least that was the case back on the afternoon of July 14, 1949, when Miss Perry posed on a picnic table in Belfast's City Park shortly after her inauguration as Maine's first broiler queen. Hastily conceived just the previous year as a trade show for the poultry industry, the first Broiler Festival had attracted some 2,000 people who gorged on 3,000 pounds of chicken cooked in an eighty-foot concrete barbecue pit, according to the *History of Belfast in the 20th Century*. By 1972 those attendance figures would spike to 17,000, as the addition of entertainment and amusements turned the event into more of a family affair (a demographic reinforced in 1985, when the city council turned down a request by the festival to host a stripper).

The shiretown at the head of Penobscot Bay had reason to coddle its appetizing export as tenderly as Miss Perry cradles it here: in 1956 poultry was the biggest agricultural commodity in Maine, bringing in $71.6 million annually, and Belfast was the undisputed king of the roost. One of the city's two factories processed up to 180,000 birds a week. (Indeed, the lads changing into their swim trunks at far left may want a shower after their dip in the bay, as the chicken blood and remnants were washed straight into the harbor for many years.) And while competition was stiff from southern processors, Maine broilers enjoyed a three- to five-cent premium due to their superior quality. But by the 1980s the Maine broiler industry had all but collapsed, and, despite being rechristened as the Bay Festival, the annual gathering soon lost its cluck. A couple of years ago a last-ditch effort to invigorate the fair by moving the festivities downtown was stymied over concerns about access to the waterfront and the need to close several streets.

But such events couldn't have been farther from the mind of Miss Perry when she sat on this Belfast beach nearly sixty years ago, her hands clutching the chicken as if it were a family pet. "It was a life-changing experience for me," says the former queen, who now lives in California. "I came from a very poor family and I got a new wardrobe, flew in a plane—all things I never would have gotten to do otherwise." Her fortune came with a price though: a clucking companion accompanied her and all future broiler queens at public appearances. In the end, surely it must have been easier for this queen to give up the bird rather than the crown when her reign ended.

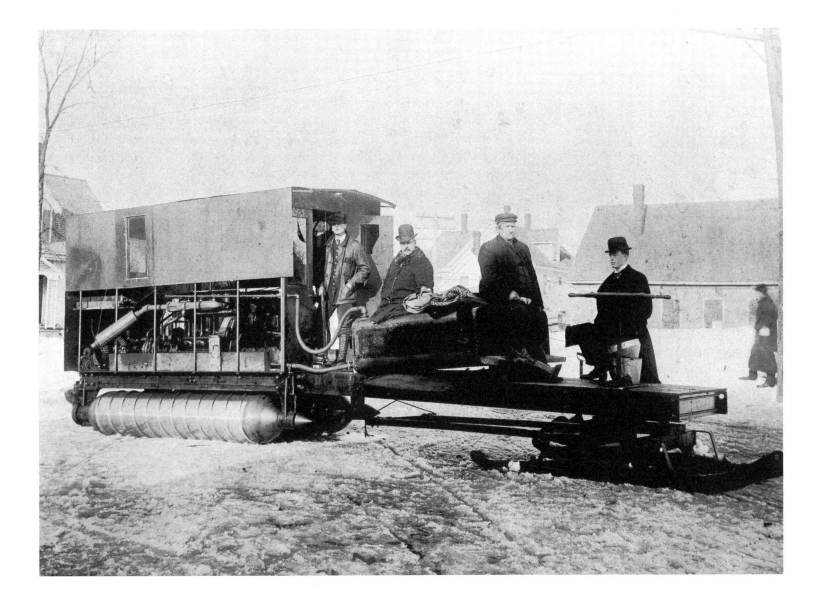

North Woods Wonder

A North Woods contraption attracted inquisitive onlookers in 1909.

Bring out a new machine and every self-respecting man in town will need to have a look. Especially back in 1909, when this striking photograph was made, the sight of a futuristic-looking, gas-powered log-hauler in a North Woods logging community was enough to draw a group of admirers. Add the fact that the contraption was developed by James Peavey, whose grandfather had invented the indispensable logging tool that bears his name, and every male resident of this small community—possibly Patten—had to take a peek. For the fellow in the lace-up leather boots at center, the appeal may be the impressive set of gears at far left that will transfer power to the pair of worm-drive rollers underneath the machine. These pontoon-like cylinders moved the vehicle forward by the same action a screw goes through wood. The fellow with his foot upon the platform at far right, possibly a manager for Great Northern Paper or one of the other mighty timber companies of the day, is almost surely considering how many sleds loaded with freshly cut logs the futuristic machine will be able to pull—and how much more profit he will be able to extract from the Maine woods. The gentleman second from right, still clutching his wrench as he sits on the fuel tank at center, may well be the brave steersman, and he is probably thinking of how difficult it will be to steer the brakeless machine with the horizontally mounted, spoked wheel at right. He may not want to think about how cold his job will be, as this machine's steering station is completely unprotected from the bitter cold temperatures that have turned this downtown street into a sea of frozen slush, its surface carved by a handful of wagon-wheel tracks, at center. In contrast, the steam-powered log-hauler invented just a few years earlier by Waterville's Alvin O. Lombard, which went on to lay the groundwork for the modern military tank, included a small shelter for the driver.

For all their interest and apparent pride, these men would probably have been disappointed to learn that this log-hauler would not revolutionize the logging industry. Although effective for traveling across hard-packed snow and ice, Peavey's creation became bogged down when it encountered soft snow, its worm-drives serving to dig a hole rather than propel the vehicle forward. While Lombard's log-hauler remained a significant lumbering tool for another two decades until trucks took over the North Woods, the machine being admired here was abandoned after just a single season of trials.

Perhaps these North Woods men should have taken a cue from the woman, at far right, who shuffles underneath newly installed power lines, paying no mind to these boys and their new toy—or the photographer who is trying to make a formal portrait.

Souvenir of Maine

A denizen of the North Woods

was headed for a warmer home

nearly a century ago.

You often saw some interesting characters at the loading dock of the American Railway Express office on Hammond Street in Bangor during the mid-1920s—but usually of the two-legged variety. It is no surprise, therefore, that the sight of a 1,200-pound bull moose standing on the platform was enough to entice these four gentlemen outside on a chilly November day to pose for a photograph with it. And while the stature and antler spread of the three-year-old denizen of the North Woods is impressive enough, his destination is even more striking. Moose—like most Mainers—prefer cool regions, and so the Italian commander who presumably shot this beast knew such a trophy would turn heads back at his home on the sunny Mediterranean.

Such an unusual parcel was enough, apparently, to convince the railway manager in Bangor, second from left, to pose for the photographer, who must have stood on the opposite platform—or even an empty railcar—to capture this arresting image. American Railway Express, the freight carrier formed during World War I, may have hoped to use the photograph in its marketing—an increasingly important part of the rail business as automobiles, and soon trucks, would begin carrying much of the cargo, including the wooden crates stacked at far left, that was the bread and butter of shipping companies.

But the manager and the assistant to his right weren't the only people seeking to capitalize on Bangor's unusual export. The proud fellow standing between the moose and its crate may well be Bangor taxidermist Fred C.N. Parke, who mounted the impressive animal and whose hammer-wielding assistant, just under the moose's head, seems frozen and eager to get on with loading it into the wooden crate that has been dragged out of the open door behind it. The antlers of this great beast will be unscrewed prior to shipping, but otherwise this massive Maine native will make his transAtlantic voyage whole and standing up.

The railroad manager and the taxidermist are so intent on posing for the camera that they seem completely unaware that their foursome is actually a fivesome. In the window at far right behind the huge crate is the unmistakable visage of a woman, most likely the manager's own clerk, whose attention has been drawn not to the creature positioned on the platform, but to the cameraman outside. From within the warmth of her office—it's so cozy there, in fact, that she's even lowered the upper sash a bit—she must be marveling at the lengths to which men will go, from shipping a full-bodied moose to braving a harsh November chill, for a souvenir of Maine.

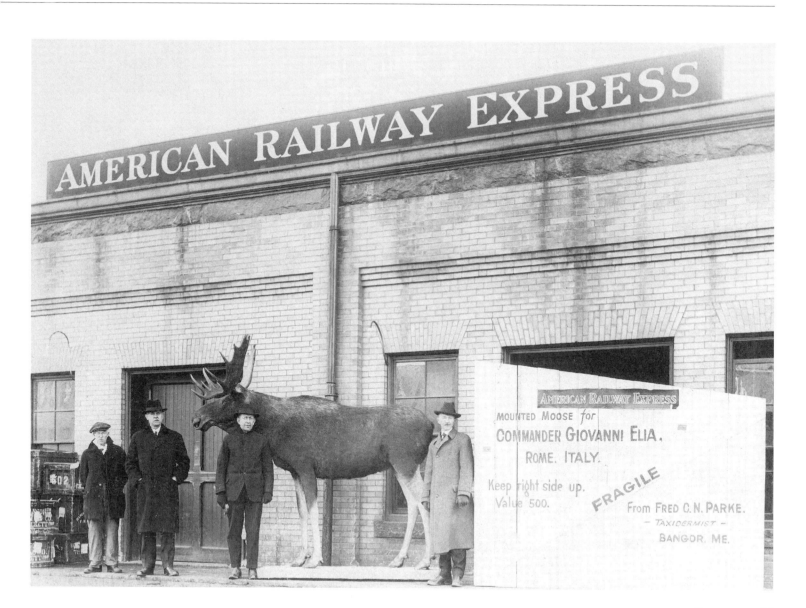

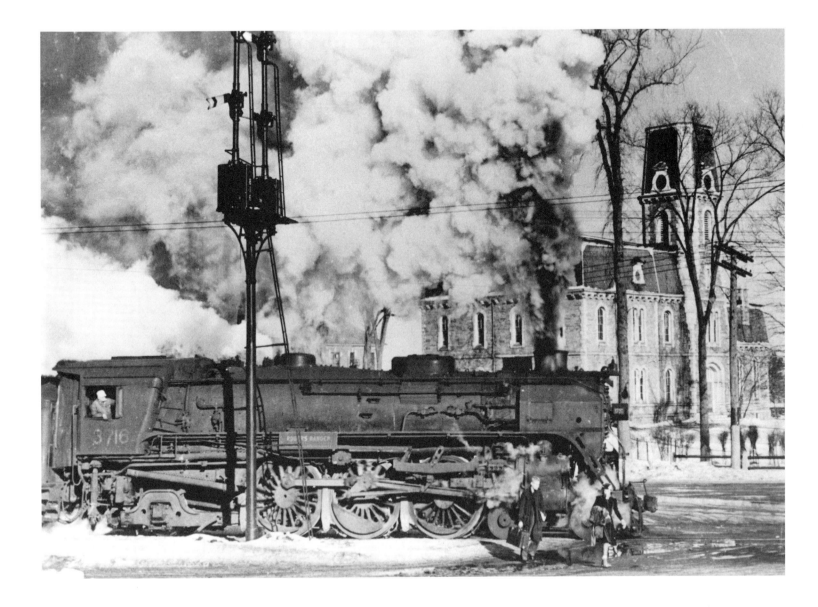

Bold Steps

Some daring students and a careful photographer helped create modern-day Colby College.

Step lively, please. That's surely what was going through Joseph Coburn Smith's mind when he snapped this dramatic photograph of two college students, just right of center, stepping in front of a steam locomotive as it passed through the original Colby College campus on the bank of the Kennebec River back in the 1930s. With Colby's thirty-acre campus squeezed tightly between the river and the railroad's repair yards, undergrads had for years played a game of cat-and-mouse with trains from the Maine Central Railroad, such as the "Roger's Ranger" shown here, some of which seemed to stretch forever as they hauled potatoes from The County to Portland and points beyond. "Only the agility of youth can explain why lives were not lost" during such crossings, wrote graduate John J. Pullen. The book and briefcase in the hands of the fellow just right of center indicate that he and his smartly dressed female companion, her overcoat draped over her arm during a February thaw, were perhaps on their way from class in Memorial Hall, at right. (Pullen also notes that coeds were known to race a train in order to get to romantic reunions on the other side of the tracks.)

Despite the perilous scene shown here, the Maine Central maintained a clean record at Colby, as engineers such as the one at far left had grown accustomed to such displays of youthful bravado, just as students themselves had become used to being "lulled to slumber by the monotonous thundering rumble" of the iron giants. But the danger was precisely what photographer Smith, the college's first director of public relations, was out to capture in this photograph. It would be used as graphic evidence of the problems facing Colby's cramped campus—the smoke and soot from the locomotive nearly obscures the buildings beyond—and to encourage contributors recovering from the Depression to fund a sprawling new campus atop Mayflower Hill. Miller Library, the first building erected on the new campus and the place where this historic image now resides, opened in 1946, followed by some sixty-one other structures—and, happily, no railroad tracks—on the 600-acre site.

White Hate

A holiday march revealed an

ugly side of Maine in 1923.

Residents of tiny Milo had no idea they'd make history when they turned out for the town's centennial celebration on Labor Day back in 1923, but thanks to this photograph by Elton Clement, the sedate township became forever linked to an ugly display of intolerance. Here, for the first time anywhere in the country, more than seventy-five members of the Ku Klux Klan marched in broad daylight, white robes and pointed hoods serving as unabashed displays of their vision of "pure Americanism." Unlike the racial segregation the Klan advocated in the South, the group's message in Maine was more xenophobic, urging its members to reject immigrants, most of whom were Catholics (and Democrats). To the Klan, which viewed Catholics' allegiance to the foreign-born Pope as distinctly un-American, Maine should remain white and Protestant.

Remarkably, on this festive summer day where bunting hangs from every eave and flags are draped everywhere, the thousands of people lining the parade route appear quiet and reserved. A shopkeeper casually smokes in the doorway of F.S. Treat's jewelry and optometrist's shop at far left, and the boy in front of him remains seated on the sidewalk. Other than the young men—likely Masons, judging by their aprons—preceding the Klansmen, no one is waving a flag. A few of the people standing in front of Peakes Market, just left of center, and elsewhere along Main Street may be anti-Klan Democrats who reportedly taunted the Klansmen as they passed, but most, including the men and women leaning against the Model Ts in the foreground, appear unfazed by the spectacle. One of the most interested spectators, it seems, is the young child peering out of the second-floor window at far left, probably unaware that these masked men are an ugly, and unwelcome, addition to the town's holiday celebration.

The Klan's rise in Maine was short-lived. Under the leadership of F. Eugene Farnsworth it had some 20,000 members in 1924, electing local candidates in Portland, Sanford, Saco, and Rockland. Despite such successes, by 1931 the Depression and the Klan's appalling racial violence in the South caused its Maine membership to dwindle to just 188 members.

But on this summer day in Milo not all the Klansmen were able to hide under their hoods; before local police allowed them to march in the parade, they required two members, at left, to reveal their faces so that constables such as the one visible just behind the streetlight at right would know whom to arrest should violence erupt. In fact, no blood was shed along the parade route, but stern words were almost surely exchanged in dozens of area farmhouses that evening as angry housewives sought an explanation for their pilfered linen closets and missing bedsheets.

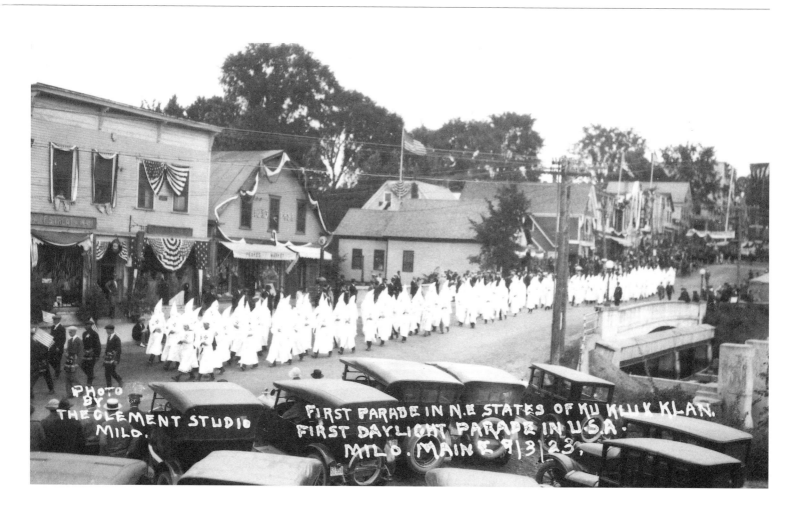

FIRST PARADE IN N.E. STATES OF KU KLUX KLAN.
FIRST DAYLIGHT PARADE IN U.S.A.
MILO. MAINE 9/3/23.

PHOTO BY
THE CLEMENT STUDIO
MILO.

One Wrong Turn

A group of Saco youngsters couldn't resist posing with a wrecked Packard back in 1914.

June 25, 1914, had begun beautifully for prominent Biddeford businessman William Carville. The sun was shining and the well-to-do soap manufacturer was enjoying the fine leather upholstery of his 1914 Packard open touring car as he rolled along Seaside Avenue in Saco. Unfortunately, Carville's day took a distinct turn for the worse at about 11:30 a.m. when he veered off the wooden bridge over Goosefare Brook and rolled his vehicle into the tidal marsh below, nearly drowning before managing to extricate himself.

By the time Saco photographer Charles E. Moody arrived on the scene and snapped this striking image, Carville's grand motorcar has already been rolled back onto its wheels (the timbers used to overturn it are stacked at upper left), and a stout line is tied to its front bumper, at far right, so the machine can be towed out of its precarious position in the riparian area. Remarkably, damage to the Packard appears limited to a broken left headlight, dented front fender, and the now-askew chrome running board just left of center. (Hopefully, for the sake of the countless plants and animals that live in this pristine marsh, now part of the Rachel Carson National Wildlife Refuge, the gas tank hidden under the driver's seat also remains intact.) The wooden bridge behind the Packard appears to have been less fortunate, with broken timbers littering the tall grass behind the convertible's top and a jagged piece of wood floating in the water just at the bottom of the photograph. The large beam resting at an awkward angle at upper left is all that remains of the wooden guardrail that Carville destroyed.

For the six children—local schoolchildren, perhaps, or enterprising lads earning a few pennies by stacking hay into the piles visible just above center—and three women who stopped by Goosefare Brook to watch this scene unfold, the wreck appears less interesting than Moody and his camera, as the children squint and the women shield their eyes from the early summer sun while looking directly at the photographer.

Despite his interest in the camera, the dapper lad in his cap and tie, at center, seems old enough to yearn to fire up Carville's fine automobile—its princely sticker price of about $3,500 (only a few years later, Henry Ford's Model T would sell for just $275) made it as much a status symbol as a means of transportation—and drive it out of the marshy brook himself. Before he does, however, he might like to know that one of the distinctive features of this luxury vehicle—its right-hand steering wheel—will soon be phased out, as manufacturers realized that placing a steering wheel on the left might actually lead to fewer crashes—a fact that Carville learned the hard way back on that pleasant summer's day nearly a century ago.

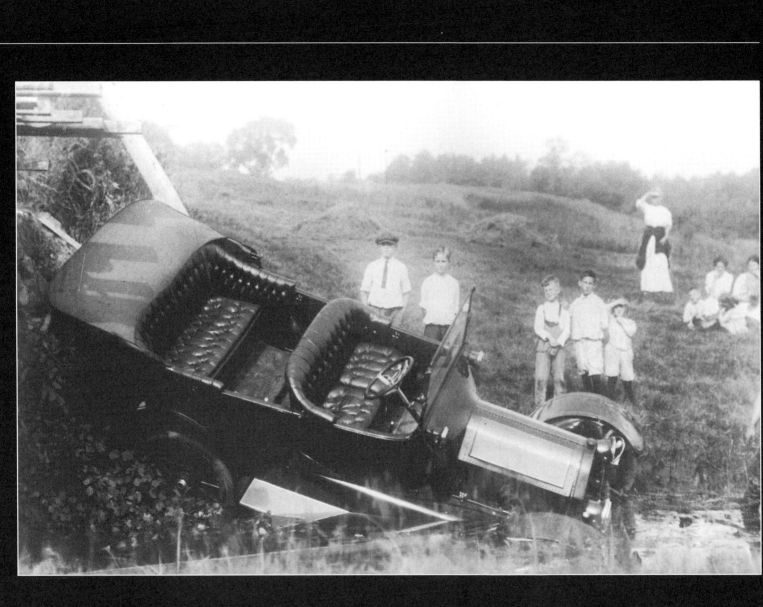

Crumbling Classic

A war hero's great Thomaston home was no match for the ravages of age and neglect.

General Henry Knox might have taken up arms if he had lived to see this photograph, made around 1870, of his once-proud Thomaston mansion literally falling to pieces. George Washington's secretary of war would likely have bristled to see the impressive front staircase where he greeted noted dignitaries replaced by a precarious assembly of warped and rotten lumber, or the brick foundation that once supported his oval great room and the home's towering chimneys now resembling targets that have borne the brunt of British cannonballs.

But Knox had already been dead for more than half a century when a local photographer captured this striking image, and Montpelier, Knox's nineteen-room mansion—reputed to be the most elegant in New England, it was designed to rival Monticello and Mount Vernon—had become an imposing derelict. Less than a year after this picture was made, it was razed to make way for the Knox and Lincoln Railroad line from Woolwich to neighboring Rockland.

Indeed, the fellow just left of center may well be one of Montpelier's last residents, a shipwright, perhaps, who lived in the building when it was used as a dormitory for the workers at the shipyard just across the street. The front lawn where Knox presided over birthday parties and summer celebrations appears to have been turned into a construction yard, a place where the bewhiskered gent shown here sorted and split the hackmatack knees behind him and squared off the massive timbers at far right for use in the square-riggers that were being built here.

If Knox could have looked past the dilapidation and disarray, he might have taken heart in the details that have remained, including his venetian front door, with its still-intact fanlight. An original decorative urn, at top center, clings to the crumbling balustrade on the roof, while a drape hangs inside a first-floor window, just right of center, seemingly waiting for some gracious host or hostess to draw it open.

While this scene would have saddened the famous Revolutionary War hero, Knox's faith and pride might have been restored if he'd known that more than seventy-five years after the completion of a replica of his great house just over the hill from this site, people from Thomaston and the county that bears Knox's name would still enjoy learning about the general and his family at Montpelier. If only some of the local people would bring a bit of the original Montpelier with them when they visit, as many of this proud home's details were carted off before the mansion was destroyed, including balusters that became so ubiquitous around town that they became known as "Thomaston walking sticks." Knox's magnificent creation may have disappeared, but it has not been forgotten.

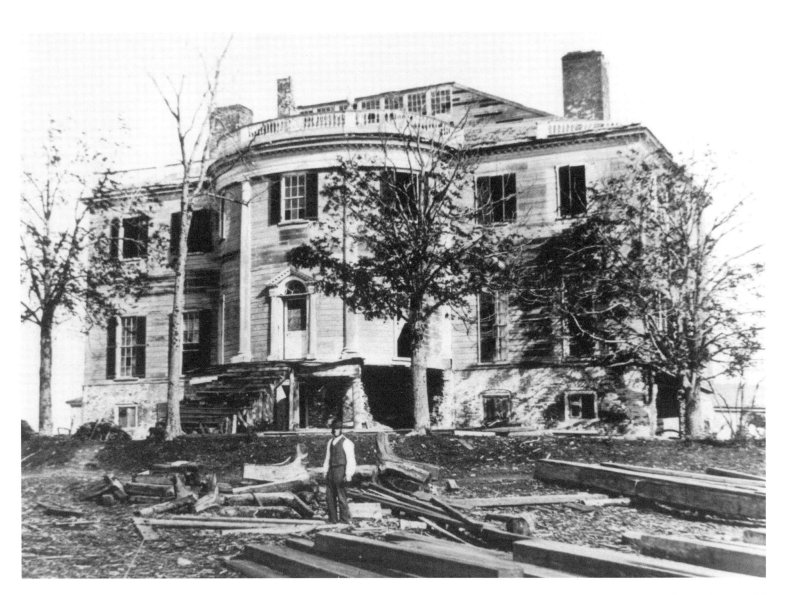

Kitchen Queen

An innovative advertising campaign promoted culinary heaven more than a century ago.

Rest assured, you who slave away in front of a hot stove: a Stanley wood-fired range purchased from the Lord & Linnell Company of Saco will transform you into a culinary queen, and the preparation of meals will become, well, heavenly. That's what William F. Linnell and Abram T. Lord hoped Maine women would think when they commissioned this striking photograph for use in their advertising back in 1900. And they knew what would appeal to women of the time: Lord & Linnell had been the exclusive agents for the trusted, Auburn-built Stanley ranges from their storefront at 113 Main Street since shortly after returning from battle in the Civil War.

The men's business acumen—as well as a downright neighborly relationship—is likely what drew them to the photographers at Webber Studios, just over a block away from their Saco retail shop, to make this impressive advertising illustration. The men have chosen and dressed their model, believed to be Linnell's sister-in-law, Laura Shepherd, who was visiting from Pennsylvania at the time, carefully to ensure she will appeal to the homemakers who comprise their clientele: she appears heavily corseted, wears a wedding band on her left hand, and seems content holding a cook pot.

But such subtle touches of domesticity apparently were not enough for these two Saco entrepreneurs, and they have attached metallic stars, moons, funnels, ladles, and flour-sifters, at lower right, to the model's flowing dress. An elaborate diadem rests on the woman's head, a homespun bit of artistry that appears to have been fabricated from a length of stovepipe. Unfortunately for this compliant model, Lord & Linnell decided to go even further with this inspired bit of metalwork, adding a frilly metal collar—a sort of turn-of-the-century Slinky—with its sharp edges serving as a painful reminder to remain motionless.

Despite such an innovative advertising campaign, the partnership of Lord & Linnell would come to an end only a few years after this striking photograph was made. While Abram T. Lord and his son opened a new stove shop just down the road in 1906, William F. Linnell did not join them.

The many subtle touches that Lord & Linnell conceived for this arresting bit of advertising were in fact quite daring—the tropical backdrop alone is startling in then-industrial Saco—but they had enough business sense to include one instantly recognizable icon. At the top of the cloth banner the men have added a tiny model of one of their trademark Stanley stoves—a final and perfectly clear symbol of the culinary heaven that these two imaginative Saco businessmen and their queenly model were offering Mainers everywhere.

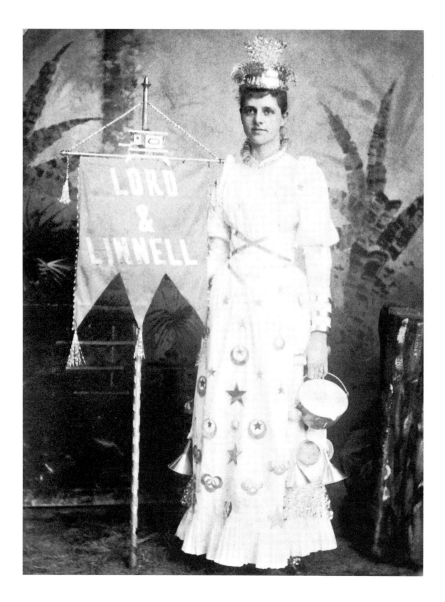

Ice Palace

A winter fire froze an Augusta landmark but not the spirit of the local firefighters.

On the morning of December 30, 1890, professional photographer George O. Ayre persuaded nine Augusta firefighters, three policemen, and several bundled-up businessmen, women, and children to pause in temperatures of more than twenty degrees below zero to pose before the ice-covered remains of one of the city's most spectacular fires. The grand civic auditorium known as Granite Hall, the site of legislative receptions, Civil War veterans' reunions, and countless concerts, dances, and plays, had caught fire only a few hours earlier. Oddly, these twenty-seven people actually appear proud to be arrayed in front of the mammoth ice sculpture, as though they were taking pride in its creation. Then again, maybe they're just cold.

When it first opened in 1866, the magnificent, three-story Granite Hall housed shops on its first floor (dilapidated signs and awnings from these commercial spaces, at left, are still visible in disarray), while steps and a grand entrance led to offices on its second level, where a stream of water now appears to be still trained on the building.

By the time Ayre captured this historic image, this light-gray Market Square edifice, by far the largest building in the heart of downtown Augusta, had already established itself as the cultural and civic center of the capital city. Although the mansard roof has collapsed and the blaze has reduced the hall's hundred-foot-long stage, colorful frescoes, and gas lamps to rubble, the helmeted firemen and others assembled here were probably fairly confident that a landmark of this significance would somehow be rebuilt.

"This was a building worthy of the state capital," explains Anthony Douin, an Augusta antiquarian. "When fires like this one happened, they didn't tear the building down, they worked with what they had and they rebuilt. Today that's not usually the case."

Indeed, the shadowy figure in the second-floor window just left of center may have been a firefighter inspecting the damage or perhaps even beginning to clear debris. The monumental block was, in fact, rebuilt and reopened the following year as the Opera House and, despite yet another fire only five years later, entertained thousands before a third, and final, fire in 1976 led to its demolition.

But the destructive blaze and bone-chilling cold of this winter morning have not dashed the hopes of these stalwart citizens of Augusta. Despite the horrific blaze he has witnessed and battled, one firefighter, at center, has been moved to wave an American flag above the rubble. The fire was devastating, he seems to be acknowledging, but the proud city on the Kennebec has not been defeated.

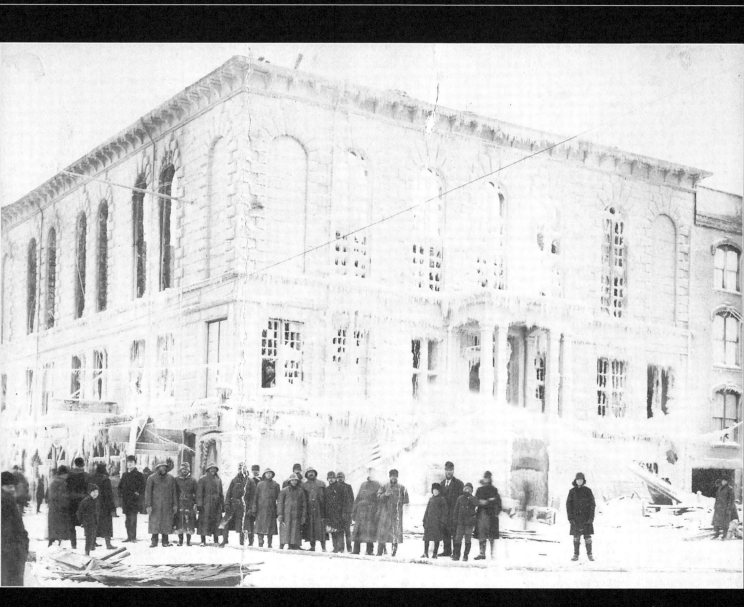

Claus
Encounter

You never knew who would drop

by Pat's Barber Shop in Augusta

twenty-five years ago.

Knowing who's been naughty and nice is a lot of responsibility, and judging by the somber look on Mr. Claus' face, this once-jolly old elf appears to be pondering trading in his annual trip down the chimney for a shave and a move south. And while Augusta barber Pat Jean, at right, looks like he might be trying to convince Santa of the merits of a trim, those who witnessed this comic encounter say the barber was actually just trying to make sure his name was on the right list. "Pat's Barber Shop was an institution in Augusta, the place where all the old people went and hung out," explains former *Kennebec Journal* photographer Jay Reiter, who used a long lens to capture this photograph through the window of Jean's barbershop at the corner of Bridge and Water streets at precisely 3:13 p.m., according to the clock at top. "Well, one of these old guys used to dress up as Santa Claus, and he was making his rounds and decided to show up at Pat's unannounced. The thing was, no one recognized him. I still remember the guys telling Santa that they'd been nice, and asking him if he was going to be nice to them that year." Reiter, whose photo likely made its way into papers across the country after it was posted on the UPI news wire, says he was never able to pry any further identification from his white-bearded subject, who maintained his character until after the newspaperman left the shop.

This contemplative Kriss Kringle might have been saddened to learn that within just a few years not only would the number of his fellow Santas in Augusta and elsewhere decline, but barbershops such as Pat's would also become increasingly rare. (Pat himself continued to keep the people of Water Street trimmed for another two decades after this photograph was taken.) These days you're more likely to find Santa posing for photos at a shopping mall than dropping by a neighborhood barbershop such as Pat's, with its signature striped pole, at left.

But this Santa could have found comfort in knowing that the holiday cheer he was spreading on this sunny Saturday in December a quarter-century ago would endure. The 4,342 volunteers in the Maine chapter of the Salvation Army, some of whom share Santa's signature coiffure and attire, annually help ring more than half a million dollars into kettles statewide. Reports of such kindness and generosity would, no doubt, have brought plenty of cheer to even this dour holiday soul.

Catch of the Day

The arrival of a favorite

fishing vessel drew much of

Vinalhaven to the wharf.

Walter Tolman knows how to draw a crowd. From the group of on-lookers, at left, who have gathered on the dock of the Lane-Libby Fisheries Company in Carvers Harbor to the piles of cod, hake, and pollock that cover his deck, the arrival of Captain Tolman, standing at lower right on the foredeck of his sloop, *Lelia E. Tolman,* was always a noteworthy event on Vinalhaven Island. Bountiful catches such as this one, captured in the nets stacked in the dories at far right during forays out to the Grand Banks, were an important part of what had built the island enterprise of Edwin Lane and Thomas Libby into the largest fish-curing plant in Maine. By the time this remarkable photograph was made in 1910, the company handled up to eight million pounds of fish each year and boasted the only cold-storage plant on the East Coast.

Tolman's impressive catch appears to have drawn one well-dressed, cigar-chomping gent, at far left, perhaps Edwin Lane himself, who no doubt wonders how many of the wooden barrels at left Tolman's load of fish will fill—and therefore how much money this catch will net his business. (The Lane family's fortunes had already grown so much that the island in the background, where their massive home is faintly visible at far left, bore their name. Today Lane's Island serves as a popular public nature preserve.) The boys at lower left are likely dreaming of one day sailing on a vessel like Tolman's and making such a historic catch. The Asian fellow at extreme left seems strikingly out of place in his tunic and cap. He's probably intent on selecting the finest fish for his employer, no doubt one of the wealthy summercators who owned the sprawling estates dotting the shoreline of both Vinalhaven and neighboring North Haven.

While most of the men gathered on this summer day nearly a century ago appear quite willing to pose in front of this photographer's camera—even the sou'wester-clad captain of the Camden-based Friendship sloop, at center, faces the lens—the person who appears most put out by the temporary work stoppage is Captain Tolman himself. He probably wanted nothing more than to unload his cargo, to fill up his vessel's one-lunger engine at the gasoline-refueling raft floating behind him, and to make for his home (and to his wife, for whom his vessel is named) on nearby Matinicus. For this proud Maine skipper, the important things in life were family, fishing, and finishing the day's work. Stopping everything to pose for a cameraman, even if he was commemorating a record catch, must have seemed an unnecessary imposition—which is just what the look on his face seems to suggest.

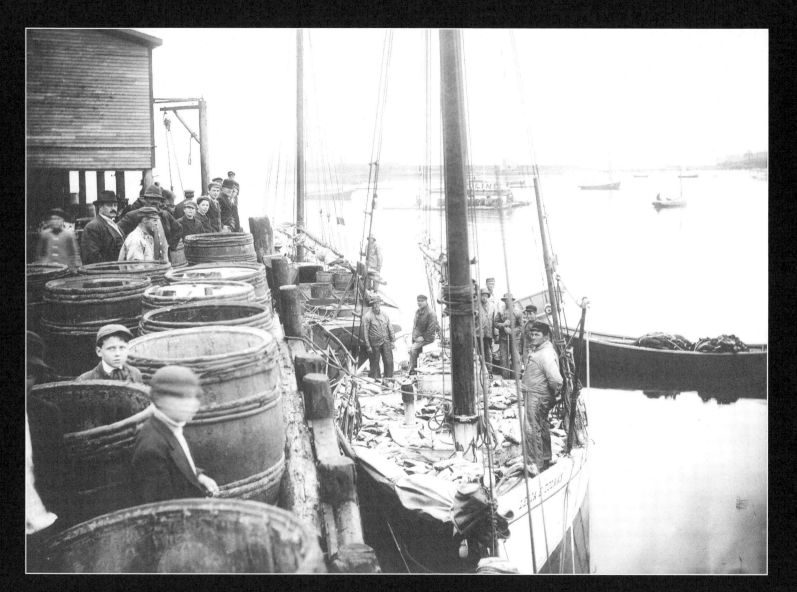

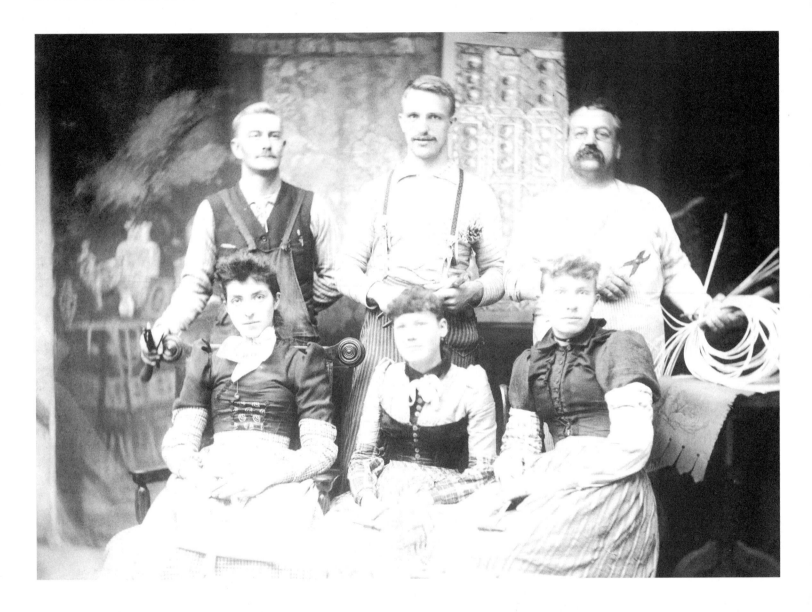

Family Business

Quality Maine furniture ran in the genes of this Norway crew.

Norway photographer Minnie F. Libby might have thought to prepare an extra chair when Otto Schnuer and his family wandered into her Cottage Street studio to pose for this occupational portrait in 1912, but then again "Miss Libby," as the renowned local photographer was known, probably felt that this family, more than any other in the area, might bring their own chairs. Schnuer, the moustached gent at far right, was known throughout western Maine for the rattan chairs and other furniture he built, proclaiming in an 1899 advertisement: "I can design a chair for you so that no one else in the world will have one like it." The hammer, shears, and roll of wicker that he holds were essential elements in the chairs, couches, and lounges he had fashioned in the two decades since he emigrated from Germany. (Judging by the ornately hemmed cloth, at far right, that the wicker rests upon, Schnuer and his relatives had added upholstering skills to their list of offerings by the time this photograph was made.) After completing stints at Benjamin Keen's chair factory in nearby Turner and at the venerable C.B. Cummings factory in Norway, Schnuer opened his own furniture shop just across the street from what would become Minnie Libby's Cottage Studio when she went into business for herself a few years later. Schnuer's stepson, Emil Herms, at top left, had joined him in the furniture business and holds a caning awl and other implements of his trade. The gent at center is likely Schnuer's son-in-law, Harlow D. Adkins, his heavy pliers and the cotton wicking that protrudes from his breast-pocket revealing his occupation as a machinist, though the tack hammer in his hands indicates that he, too, probably helped with the family's business. The women seated in the front row are likely, from left, Schnuer's daughters Friede, Alice (no doubt placed in front of Adkins because the two were married just the previous year), and his stepdaughter Clara. The photographer or the family has deliberately chosen to portray these women as part of the family business: each clutches a tack hammer, one of the tools that we are made to believe they use each day.

Even as this proud family stood for their portrait they have not forgotten to place at front and center the one item that unites them. Barely visible against the women's wide skirts, at bottom center, rests an overturned object that is more closely linked to this family's fortunes than any other—a wood and wicker chair. For this Maine family, it seems, the bonds of kinship are as strong as the fine pieces of furniture that they create.

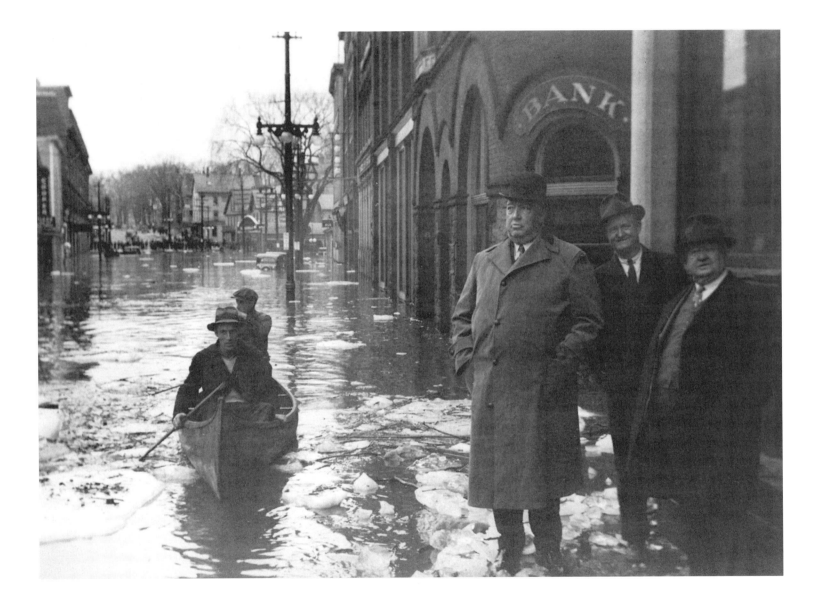

Urban
White
Water

Paddling season came early to Auburn back in 1936.

Every year Mainers yearn for spring and the waterborne joys it brings with it, but no one in Auburn expected to drag out their canoes quite so early back in 1936. Yet paddles proved far more useful than the submerged Chevies parked just left of center when the Androscoggin River began rising quickly on March 19.

Seventeen snowstorms without a thaw were followed by a soaking rain that released several ice jams, inundating the Twin Cities. Boats of every size and shape, including the canoe shown here, were launched as residents of the Shoe City attempted to rescue people trapped in their homes and salvage whatever items they could. "I could hear the swelling waters of the Androscoggin River, which was on a rampage," recalls John Robinson in an account published in the *Lewiston Journal*. "I was allowed to help in the removing of supplies from Anderson and Briggs drug store. Most of us were a high school crowd, and even in all the excitement we stopped to mix some carbonated drinks. A few minutes later we fervently wished we had not because someone thoughtfully informed us that the carbonator was under the river water." Indeed, residents of both cities were urged to boil water to prevent typhoid.

In this scene a crowd has formed, at upper left, where police have cordoned off Main Street near the round-roofed Puritan Chevrolet Company's showroom and the Maine Hotel, yet three distinguished local men have been allowed into the flood zone to survey the damage. The Hitchcock-looking fellow standing amid the fallen branches and ice cakes at right is Horace E. Munroe, whose family had built a small fortune in the local shoe industry. Joining him in front of the Mechanics Savings Bank building are John Merrill and John Cartwright, two prominent Auburn residents. Merrill and Cartwright seem pleased to mug for the camera, but Munroe's gaze is focused squarely on the North Bridge to see if it, like the South Bridge, would fall to the raging Androscoggin and thus sever the city's connection to Lewiston. Though planks were ripped from the bridge's deck and its underpinnings damaged, the fifty-year-old structure survived a whopping 212,000 cubic feet per second of water until the river receded to its normal level of 30,000 cfs.

Remarkably, despite leaving two thousand families temporarily homeless, the flood of 1936 claimed no lives in Auburn. For some people living along the Androscoggin, though, the flood was especially demoralizing as many had only just finished rebuilding the homes and businesses lost during a blaze three years earlier. Still, if the smiles on these paddlers' faces are any indication, Auburn residents were already well on their way to overcoming whatever adversity a Maine spring could throw at them.

Photo Credits

Pg 10: Down East Enterprise, Inc.

Pg 12: McArthur Public Library, Biddeford, Maine

Pg 15: The Pejepscot Historical Society

Pg 16: Bettmann/Corbis

Pg 19: Bangor Museum and Center for History

Pg 21: Maine Historical Society, Coll. 1880/Whitney Draper

Pg 22: Maine Historic Preservation Commission

Pg 25: Penobscot Marine Museum

Pg 27: Bettmann/Corbis

Pg 29: Bangor Museum and Center for History

Pg 31: Camden Area History Center/Janen Babb Vaughn

Pg 33: Camden Area History Center

Pg 34: Corbis/Jack Delano

Pg 36: Maine Historical Society

Pg 38: Maine Historical Society/United Press International

Pg 41: Down East Enterprise, Inc.

Pg 43: Old York Historical Society

Pg 44: Maine Historical Society/Fryeburg Historical Society

Pg 47: Special Collections, Fogler Library, University of Maine

Pg 48: Collection of Capt. W. J. Lewis Parker

Pg 51: Tonee Harbert/Judith Ellis Glickman Collection/Portland Museum of Art

Pg 53: Eastern Maine Medical Center

Pg 54: Bangor Museum and Center for History

Pg 57: Culver Pictures

Pg 59: Maine Historical Society

Pg 60: Wayne Wilcox

Pg 63: Special Collections, Fogler Library, University of Maine

Pg 65: Bettmann/Corbis

Pg 66: Stephen Phillips Memorial Library/Penobscot Marine Museum

Pg 69: Oakfield Railroad Museum

Pg 71: Maine Historical Society/Aroostook Historical and Art Museum

Pg 72: Captains Douglas K. and Linda J. Lee

Pg 75: Old York Historical Society

Pg 76: Maine Historical Society/United Press International/Jay Reiter

Pg 78: Maine Historic Preservation Commission

Pg 80: AP Images

Pg 83: Old York Historical Society

Pg 84: Rockport Institute for Photographic Education

Pg 86: Patten Lumbermen's Museum

Pg 89: Maine Historic Preservation Commission

Pg 90: Colby College Special Collections

Pg 93: Special Collections, Fogler Library, University of Maine

Pg 95: Special Collections, Fogler Library, University of Maine

Pg 97: Collections of Montpelier, The General Henry Knox Museum

Pg 99: Down East Enterprise, Inc.

Pg 101: Maine Historic Preservation Commission

Pg 103: Maine Historical Society/Jay Reiter

Pg 105: Maine Historic Preservation Commission

Pg 106: Maine Historic Preservation Commission

Pg 108: Androscoggin Historical Society